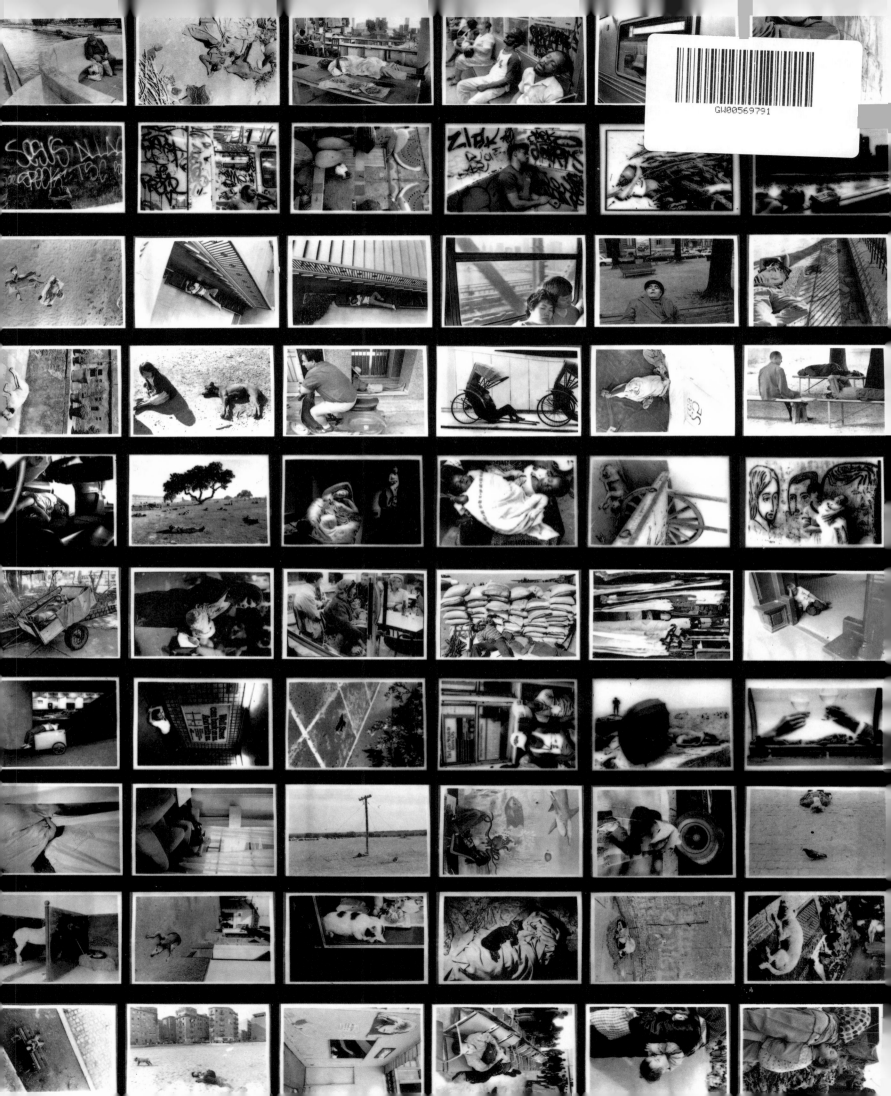

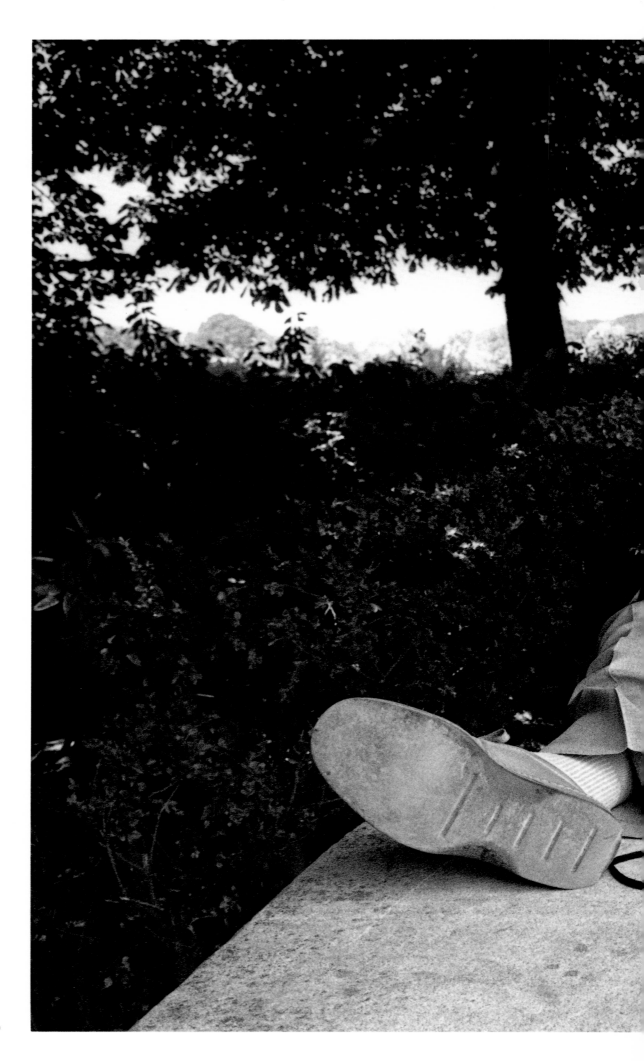

paris france 1980

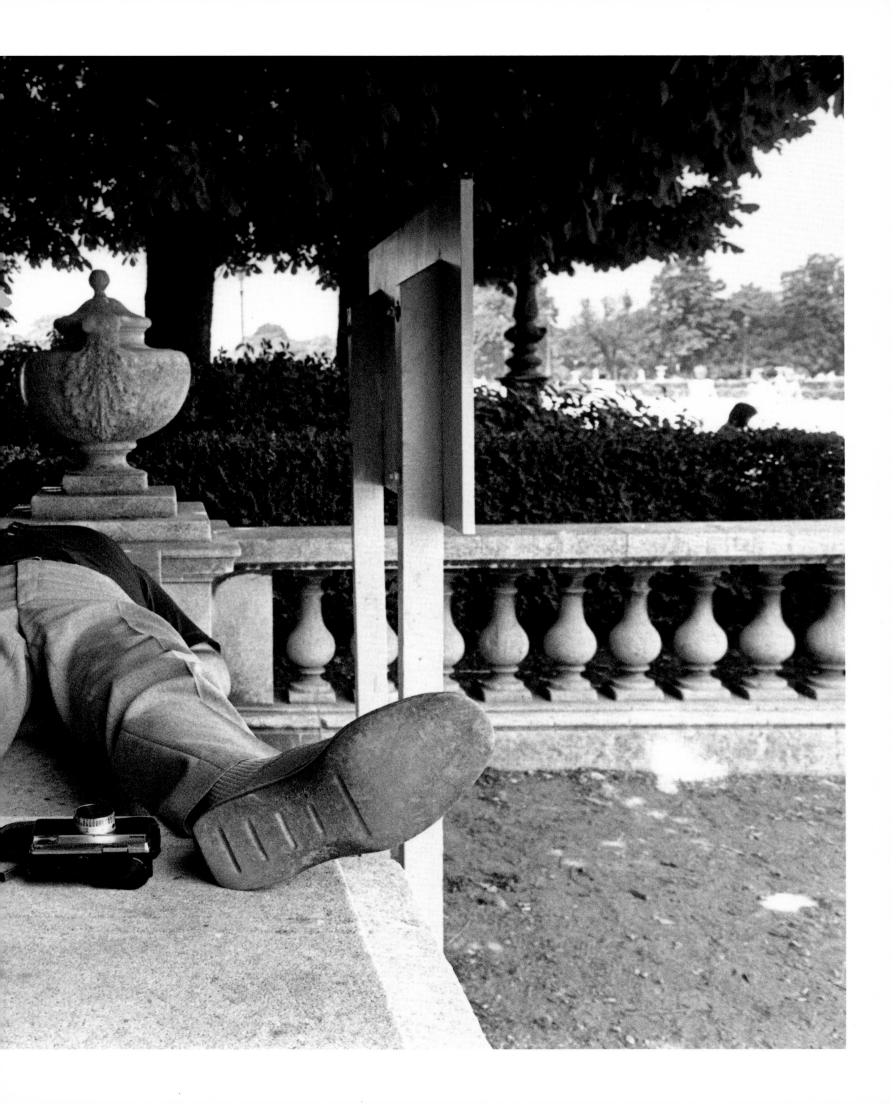

to sleep, perchance to dream

photographs by ferdinando scianna

to sleep, perchance to dream

to sleep, perchance to dream

Φ

The photographer would like to thank the Istituto Suor Orsola Benincasa for their help in making this book; he also gratefully acknowledges Gesualdo Bufalino, who suggested the idea of 'illustrating' it with an anthology of literary fragments.

Phaidon Press Limited
Regent's Wharf
All Saints Street
London N1 9PA

First published 1997

English edition © 1997 Phaidon Press Limited
Original Italian edition first published by Art& Edizioni delle Arti Grafiche Friulane
Società Editrice S.p.A. in 1997
Photographs © 1997 Ferdinando Scianna

A CIP catalogue record for this book is available from the British Library

ISBN 0 7148 3719 9

Printed in Italy

For Paola

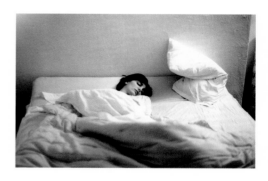

Sleep-laden eyes, black, passionate,
You have the sweetness of honey.

Salvatore di Giacomo, Nannina

A string of coral beads in a glass cup, a print of the beheading of Louis XVI, and a black missal: I had seen them so many times in the junk shop window, next to the small photograph of the sleeping girl. But the little girl, clutching her doll, had never known such squalid company. She was brought there in her sleep, and that sleep each time seemed more enchanted, and the things that she saw in her sleep appeared, from her smile, to be ever more distant and sweeter.

It was an old photograph; and the beauty of the creature whose blood had been refined by the passing of generations, her bearing and the daintiness of her clothes, and the harmonious arrangement of space and light suggested a treasure store of privileged memories, and evoked a certain perfection of living that, indelibly, imprints its seal on things, however lightly. The miserable mementoes surrounding the picture made it look nobler still, as if regretting the fate which had brought it to end up in the midst of them. There are some objects, insignificant on first sight, which take on an almost human life. And the junk dealer himself had felt it, since he expected to make a few pennies from that photograph, from the indefinable and precious charm that it exuded.

The imagined story of the photograph was more obvious than any well-known tale. Surely this had been meant as a surprise for daddy; for then, even for the rich, a photograph was something rare and memorable. And they had gone secretly to the photographer's studio, the little girl charmed and excited by the novelty of the occasion. Having laid her shawl on the carpet, the mother had placed the child on it, a lace pillow under her head. And she had arranged the little tartan skirt into pleasing folds, while the child held tightly on to her doll, cheek against cheek. Moving away at last, after a final touch to a curl to make it fall more gracefully, the mother had said, 'Now close your eyes.' And, if you stared at the portrait long enough, you could imagine her eyelids trembling, like those of someone pretending to be asleep who feels the touch of a caress. The dark velvet curtain closed behind the reclining figure in heavy swathes. And the contrast between those inanimate objects and the motionless trepidation of the child was accentuated by the glassy stare of the doll and the artifice of a rose that clasped hands appeared to have let fall on to the carpet.

The photographer busied himself with lenses and filters. And the little girl, eyes closed, remained still in that prescribed pose, imagining herself to be beautiful. She had a great desire to see what was happening in front of her and what magic was going to produce her portrait. But she couldn't. At one point, the instructions to stay still became so pressing that she really believed she could bear them no longer. Then there were some moments of unbearable silence such as might end in an explosion, or a crash. She abandoned herself to the eventuality; but nothing happened, and now they were telling her how clever she had been, and her mother ran to gather her up in her arms as if picking her up unharmed from beneath the wheels of a carriage. And not a word about the portrait. But when the mother received the package of small glossy cards, the little girl, already disillusioned, hardly looked at them, and would not even acknowledge that they were of her and her doll. After many years one of the cards came to light at the bottom of a drawer, and the child, now grown up, saw it in a

different way; she recognized herself, so to speak, and began to love it. She looked at it often. And how many times I, too, had returned to look at it.

Listening to calm and melancholy music, or when in the isolation of an illness our past is reduced to mere matter for contemplation, we are as if transported to a higher and more rarefied plane of existence. And here there is some stern yet compassionate justice, that erases any distress from uncomfortable memories, and lovingly prises us away from our very desires. So I felt on looking at that sweet picture. I fancied that the noises of the street did not touch my senses but flowered again in a distant memory. The pale shadows of passers-by flickered across the glass of the shop window. And the street trembled at the end of a used up and worn out past.

And I thought that if the girl, now woman, ever wanted to offer to someone a token of trust and love, nothing would compare with that relic of her innocent femininity, even if already rent asunder by sleepless sleep, by watchful abandon. Nothing could capture with more truthful and heartbreaking grace her first expectation – and the disappointment. She was at that age of first fantasies, when if she woke up in the night she thought she could make out words in the murmur of the rain. At the age when the first unexpected sadness could stop her in the middle of a game. And she was an emblem of childish hope, so often symbolized by artists, with a flower in her hand. But a hope mysteriously knowing and disturbed; she had kept her eyes shut, and dropped the flower.

They had made her pretend to sleep. In that pretence, she had found the truest exposure of herself, and not just of herself. From those intact forms a new, complex and different creature had taken off and had gone out into the world. And the long black curls had been stroked by other hands; gathered up into regal hairstyles. In scenarios other than the photographer's, in a bridal room, or in the secrecy of amorous trysts, once more she would have prepared herself, devoted herself to a revelation, a miracle even. But from that most trusting self-abandonment she had not derived anything but a memory of disillusion. And just as for certain poets the truest words remain those uttered in youth, so throughout her life she remained true to that first sign. She had for all time been secretly ruled by a fragile and invincible image of a sleeping beauty, who knows that it is futile to wake up.

I remembered an inscription, subtle and terrible, that one day I had read on a stranger's gravestone in a country cemetery: here he awaits the end of time. And this, I thought, awaits the unknown little girl; and we too with her, in our troubles and our transports; so that we may finally know our own truth, at the end of time.

And with the passing of the years, she has become like a sacred monument in my memory, like those marble figures of children asleep with their toys around them, that our ancestors liked to place on the tombs of those who had died young to soften the look of death. But in reality the little girl is awake. She listens to the words in the rain, and the indistinct flow of all living things. Like a compassionate angel who shares mankind's fate, lost in the middle of the world, she awaits the end of time.

Emilio Cecchi, On the Portrait of a Sleeping Girl

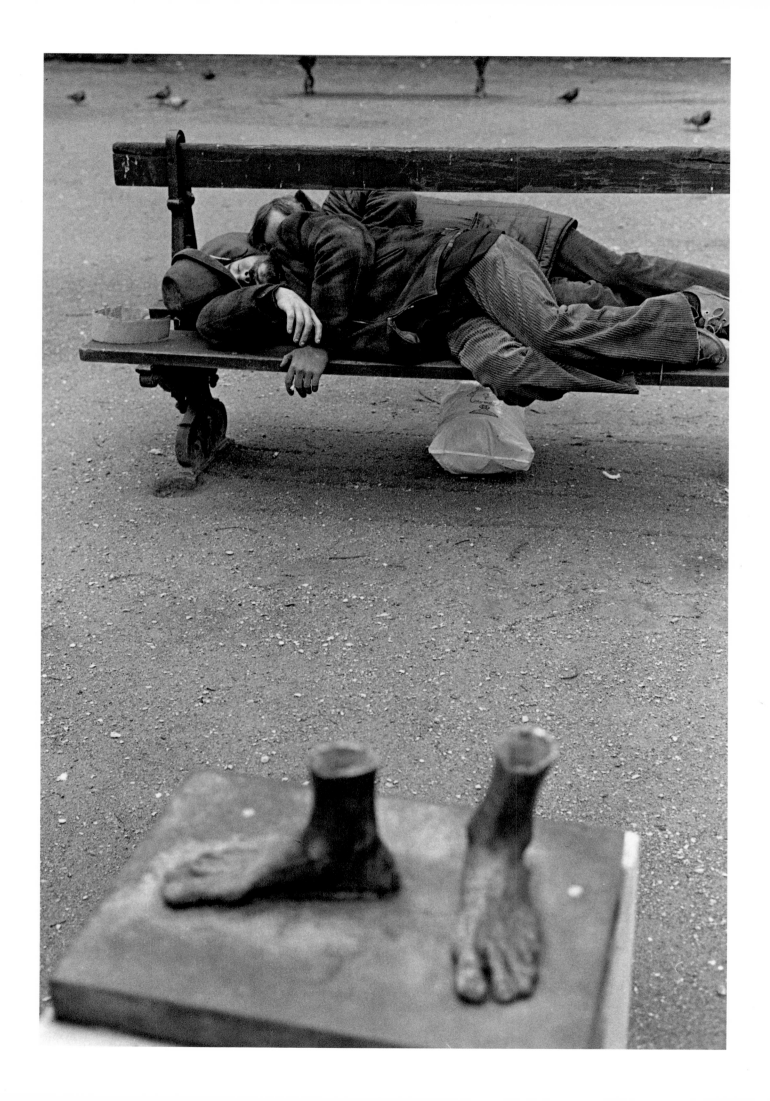

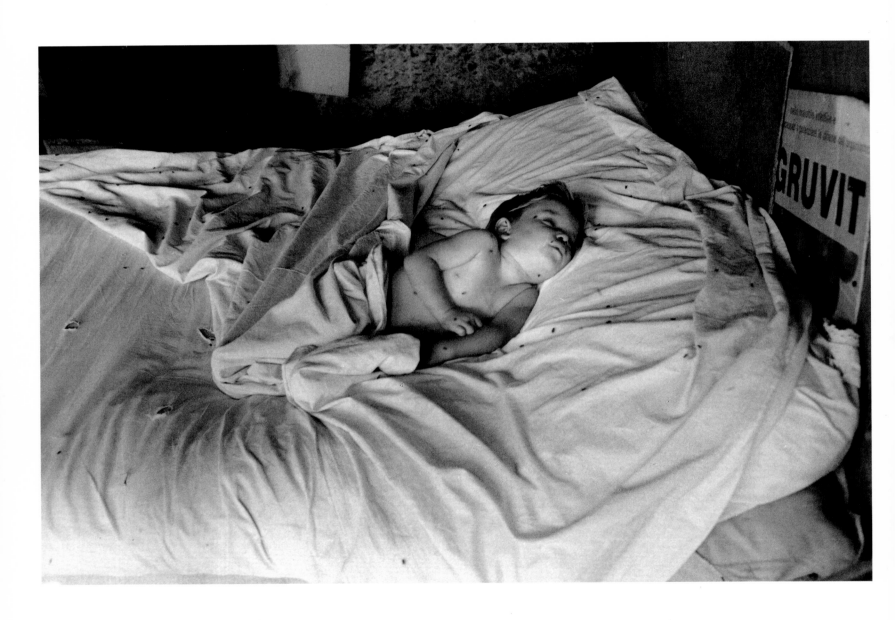

reggio calabria italy 1970

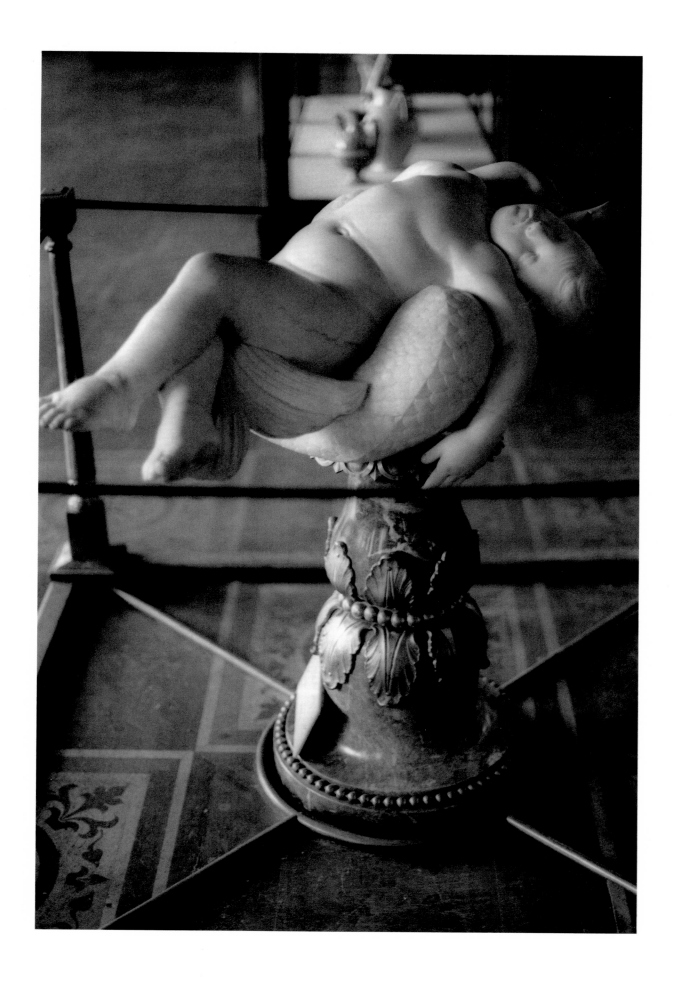

st petersburg russia 1992

We are such stuff
As dreams are made on, and our little life
Is rounded with a sleep!

William Shakespeare, The Tempest, IV.i.156–8

To live is to have an illness from which sleep affords
relief every sixteen hours. Sleep is a palliative;
death is the only remedy.

Sebastien Roch Nicolas Chamfort, Maxims and
Reflections

Death is the veil which those who live call life:
They sleep, and it is lifted.

Percy Bysshe Shelley,
Prometheus Unbound, III.iii.113–14

And I fancy that I would feel less wretched if I could
sleep a long deep sleep. Opium does not help, it wakes
me up after brief drowsy spells full of visions and
spasmodic pains, and this for several nights!

Ugo Foscolo, The Last Letters of Jacopo Ortis

One short sleep past, we wake eternally,
And death shall be no more; Death, thou shalt die.

John Donne, Holy Sonnet 10

Dreams are a disguised attempt at wish fulfilment.

Sigmund Freud, Introduction to Psychoanalysis

Life death does end and each day dies with sleep.

Gerard Manley Hopkins, No Worst, there is None

Yet a little sleep, a little slumber, a little folding of
the hands to sleep.

Proverbs 6:10

 … to keep
An incommunicable sleep.

William Wordsworth, The Affliction of Margaret

I do not love, says God, the man who does not
sleep …

Charles Péguy, The Mystery of the Holy Innocents

O Sleep, Sleep! …
Sleep who departs to the Orient
And neither Prince nor King can detain,
O Sleep, come slowly,
Put down your foot, stop here …
Be so compassionate and powerful,
Hold out your hand, and put to sleep
All of us …
Come to us, Sleep!

Salvatore di Giacomo, Let's Leave it to God

Near the Cimmerians' land a cavern lies
Deep in the hollow of a mountainside,
The home and sanctuary of lazy Sleep,
Where the sun's beams can never reach at morn
Or noon or eve, but cloudy vapours rise
In doubtful twilight; there no wakeful cock
Crows summons to the dawn, no guarding hound
The silence breaks, nor goose, a keener guard;
No creature wild or tame is heard, no sound
Of human clamour and no rustling branch.
There silence dwells: only the lazy stream
Of Lethe 'neath the rock with whisper low
O'er pebbly shallows trickling lulls to sleep.
Before the cavern's mouth lush poppies grow
And countless herbs, from whose bland essences
A drowsy infusion dewy night distils
and sprinkles sleep across the darkening world.
No doors are there for fear a hinge should creak,
No janitor before the entrance stands,
But in the midst a high-raised couch is set
Of ebony, sable and downy-soft,
And covered with a dusky counterpane,
Whereon the god, relaxed in languor, lies.
Around him everywhere in various guise
Lie empty dreams, countless as ears of corn
At harvest time or sands cast on the shore
Or leaves that fall upon the forest floor.

Ovid, Metamorphoses, XI.592–615, translated by A. D. Melville

Night with her train of stars
And her great gift of sleep.

William Ernest Henley, Echoes, iv. Invictus. In Mem.
R.T.H.B., xxxv, Margaritae Sororis

I have never found sleep to be a rest.

Gérard de Nerval, Aurélia

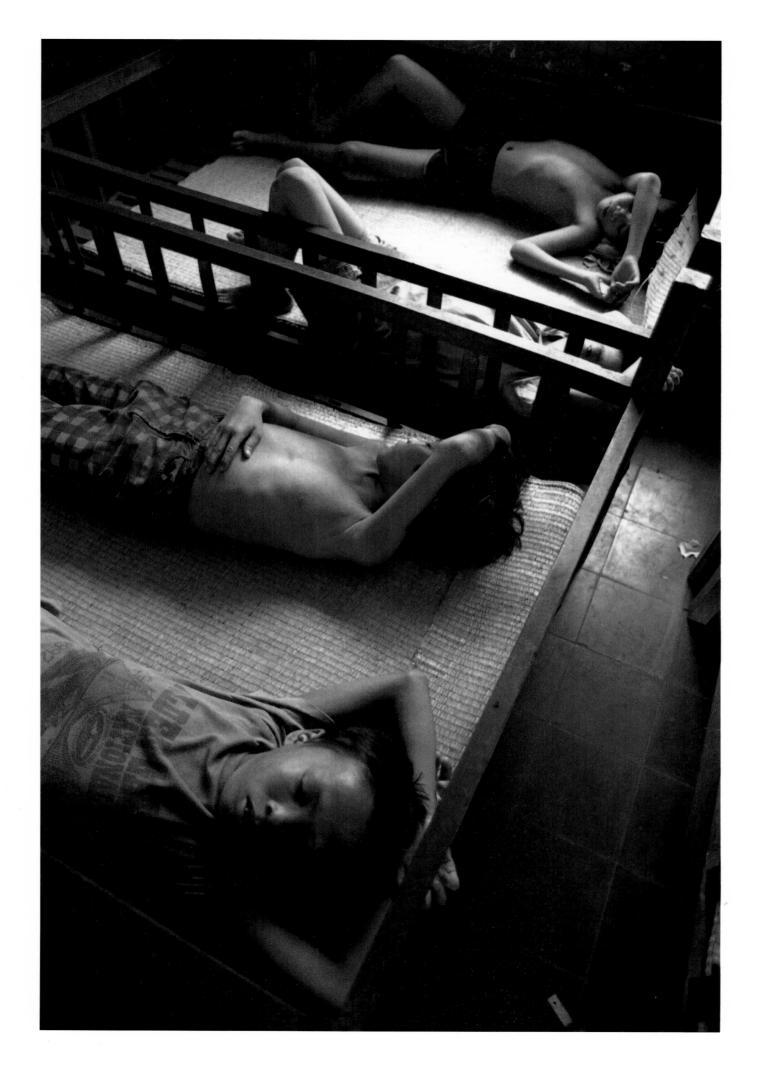

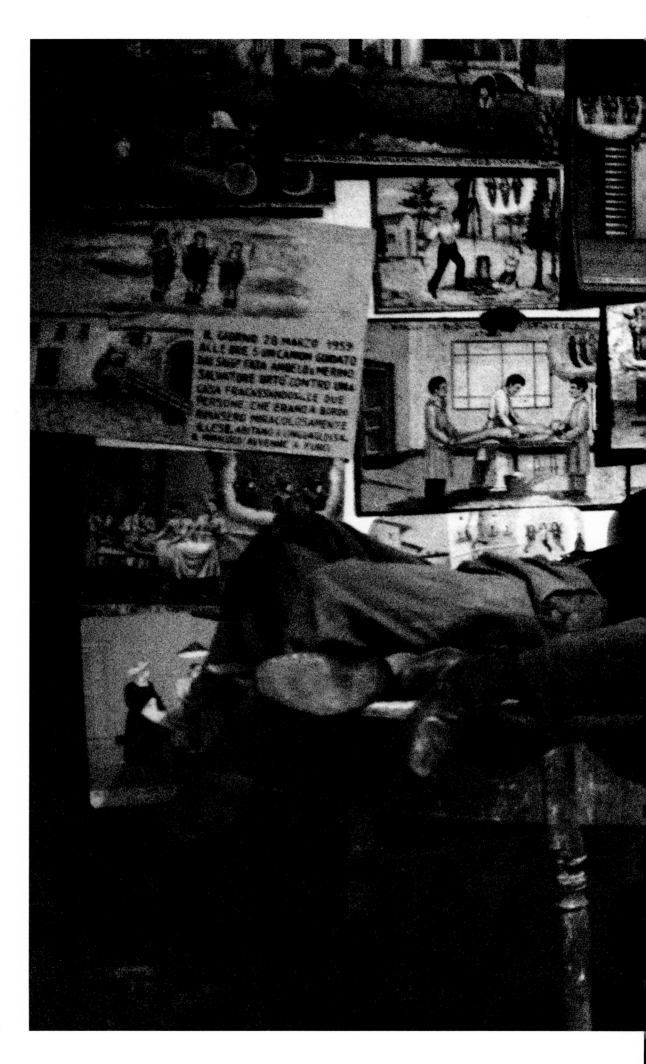

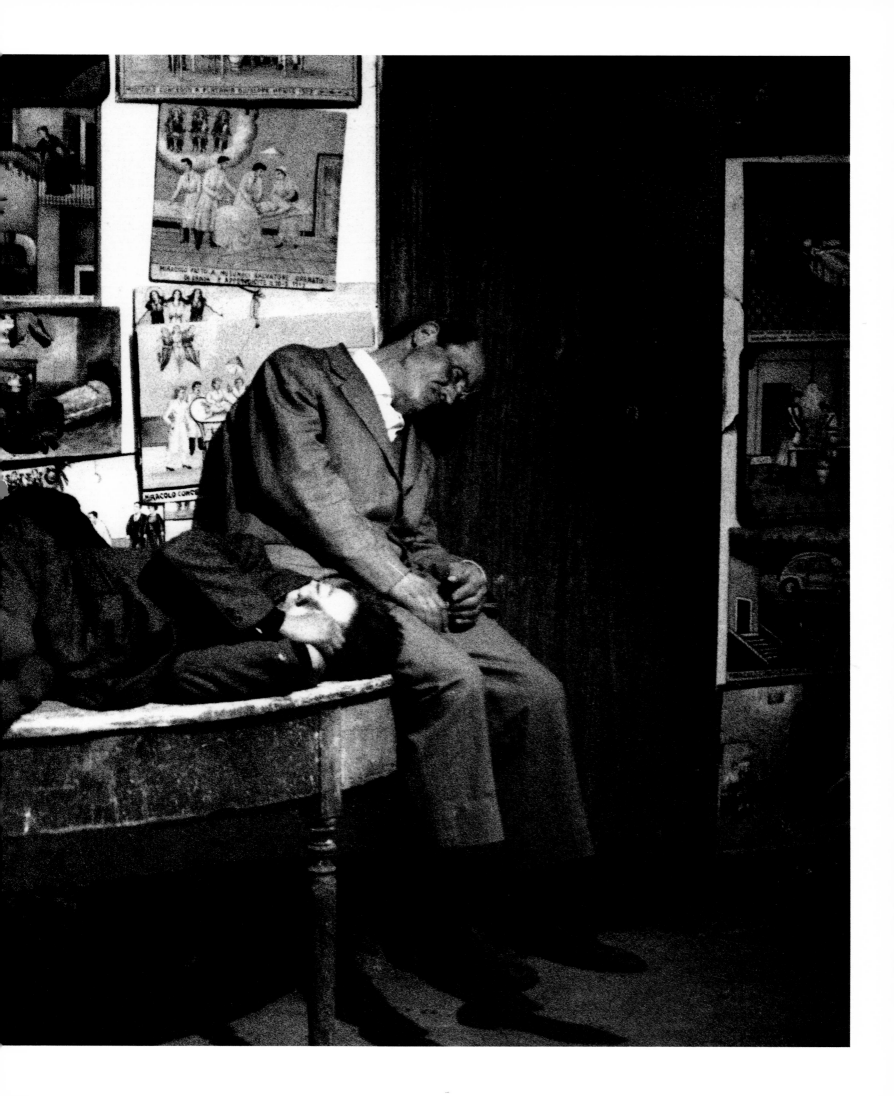

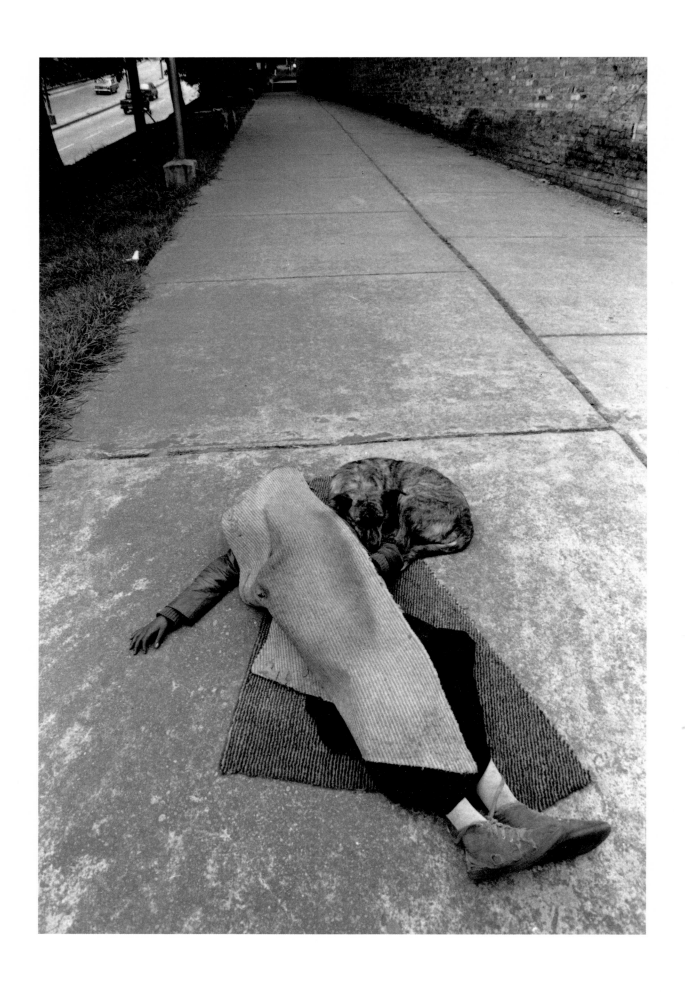

bogotá colombia 1987

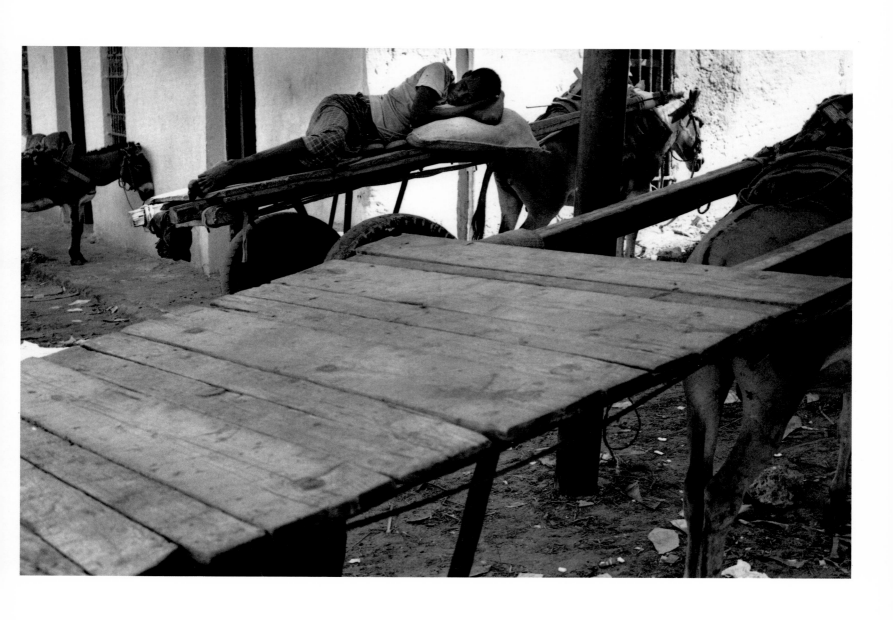

mogadishu somalia 1984

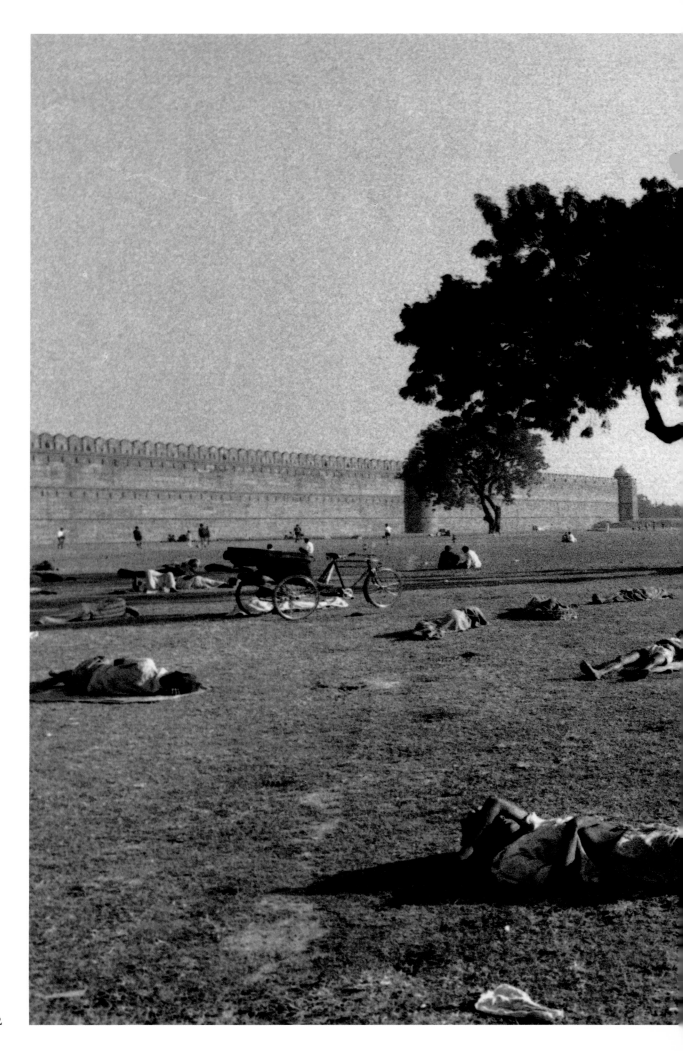

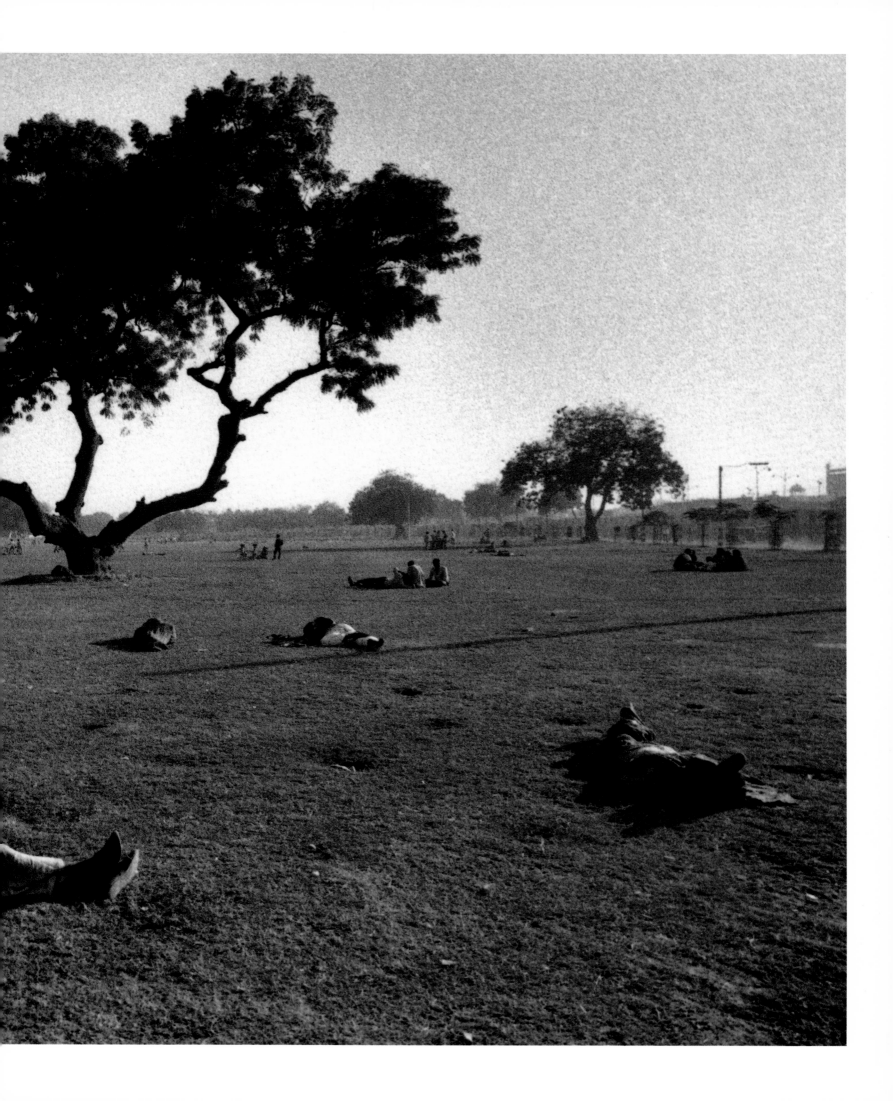

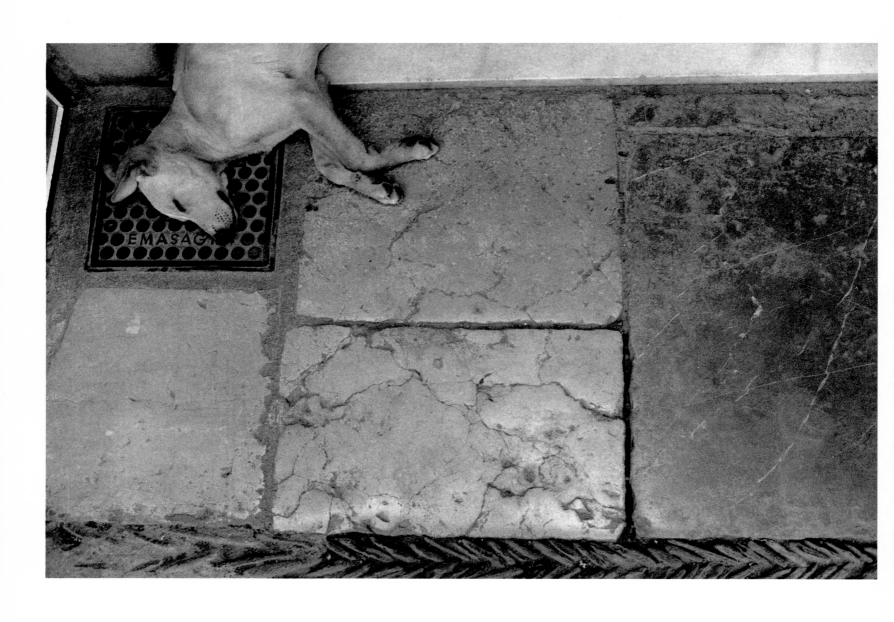

almería spain 1992

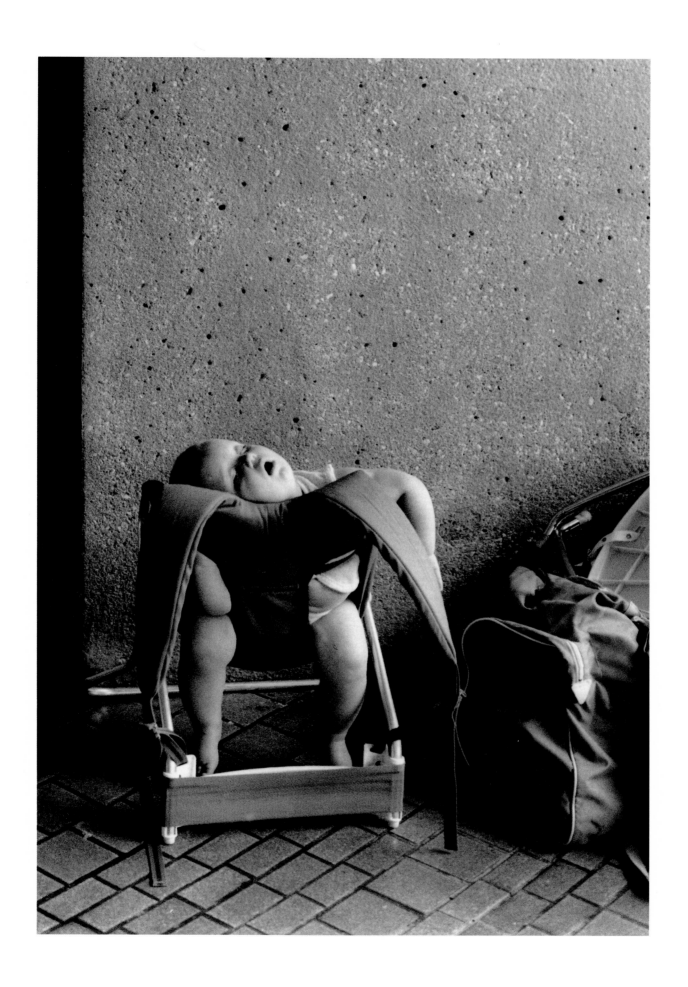

los angeles united states 1985

… but sleep at length, pain's balm
And care's sweet quiet …
Torquato Tasso, Jerusalem Delivered, VII.iv

Come now, most placid sleep
To the starving heart that desires you …
Lorenzo de' Medici, Rhymes

Sleep that no pain shall wake,
Night that no morn shall break,
Till joy shall overtake
Her perfect peace.
Christina Rossetti, Dream Land

And Night bore terrible Destiny and black Fate,
And Death and Sleep, and she bore also the brood of
dreams …
Hesiod, Theogony, 211–12

The gracious power
Of sleep's fine alchemy.
James Thomson, Insomnia

The winds come to me from the fields of sleep.
William Wordsworth, Ode. Intimations of Immortality,
part III

When you are old and gray and full of sleep,
And nodding by the fire, take down this book,
and slowly read, and dream of the soft look
Your eyes had once, and of their shadows deep.
William Butler Yeats, When You are Old

Methought I heard a voice cry, 'Sleep no more! Macbeth
Does murder sleep' – the innocent sleep,
Sleep that knits up the ravell'd sleeve of care,
The death of each day's life, sore labour's bath,
Balm of hurt minds, great nature's second course,
Chief nourisher in life's feast.
William Shakespeare, Macbeth, II.ii.37–41

The child's sleep was short. He woke without a
start, and went on to talk as if his sleep had been
only a pause in his breathing.
Roberto Piumini, Lo Stralisco

Thy brother death came, and cried,
 Wouldst thou me?
Thy sweet child Sleep, the filmy-eyed,
 Murmured like a noontide bee,
 Shall I nestle near thy side?
 Wouldst thou me?
Percy Bysshe Shelley, To Night

Tell me not, in mournful numbers,
Life is but an empty dream!
For the soul is dead that slumbers,
And things are not what they seem.
Henry Wadsworth Longfellow, A Psalm of Life

Here, where the world is quiet;
Here, where all trouble seems
Dead winds' and spent waves' riot
In doubtful dreams of dreams.
Algernon Charles Swinburne, The Garden of Proserpine

Hush! my dear, lie still and slumber,
 Holy angels guard thy bed!
Heavenly blessings without number
 Gently falling on thy head.
Isaac Watts, Cradle Hymn

O soft embalmer of the still midnight,
Shutting, with careful fingers and benign,
Our gloom-pleas'd eyes.
John Keats, To Sleep

Surely, surely, slumber is more sweet than toil, the shore
Than labour in the deep mid-ocean, wind and wave and oar;
O rest ye, brother mariners, we will not wander more.
Alfred, Lord Tennyson, The Lotos-Eaters

Sleep has taken your form
And the colour of your eyes.
Paul Eluard, Sleep

If thou wilt ease thine heart
Of love and all its smart,
Then sleep, dear, sleep.
Thomas Lovell Beddoes, Death's Jest Book, II.ii

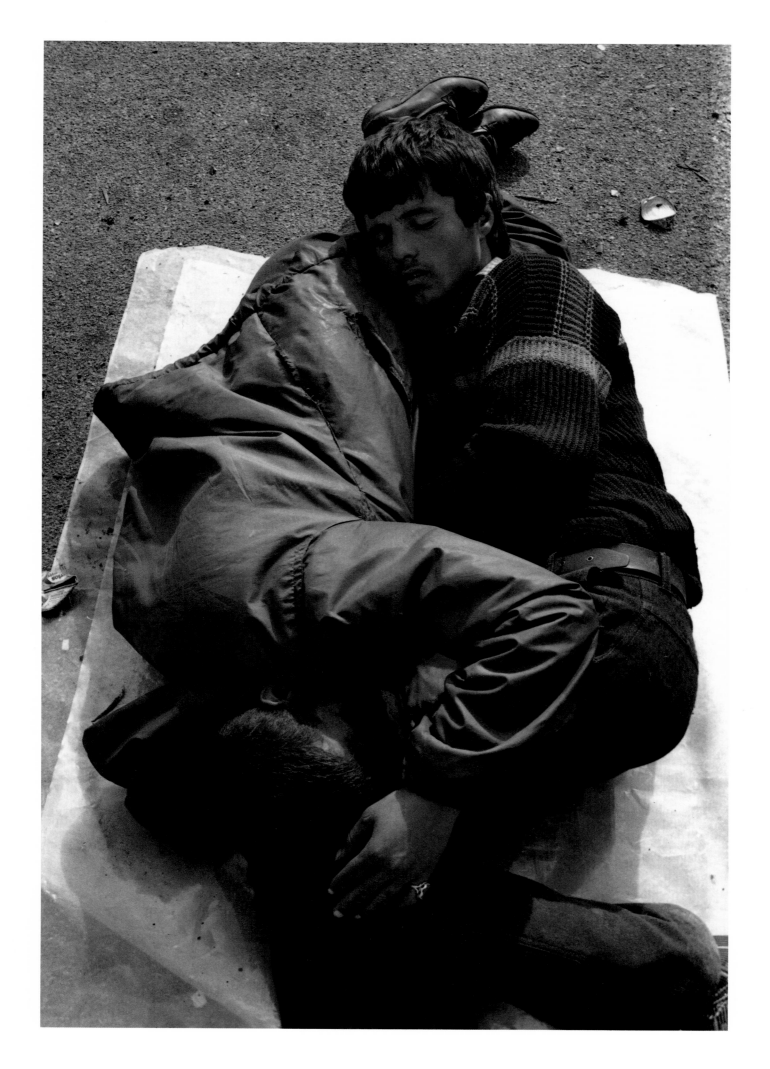

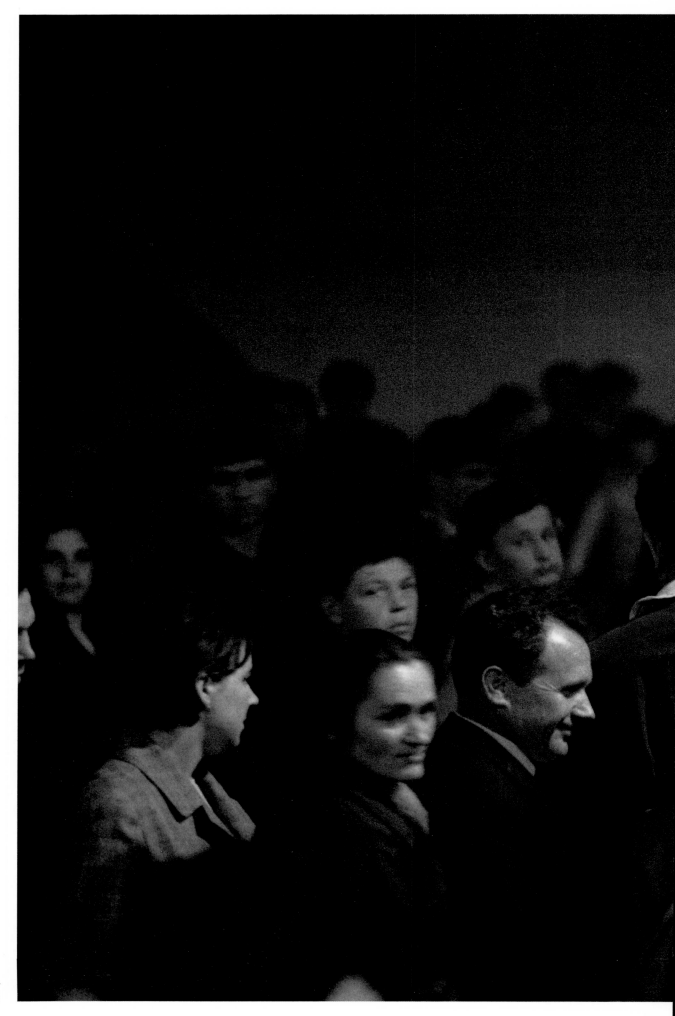

kladanj
bosnia-hercegovina 1969

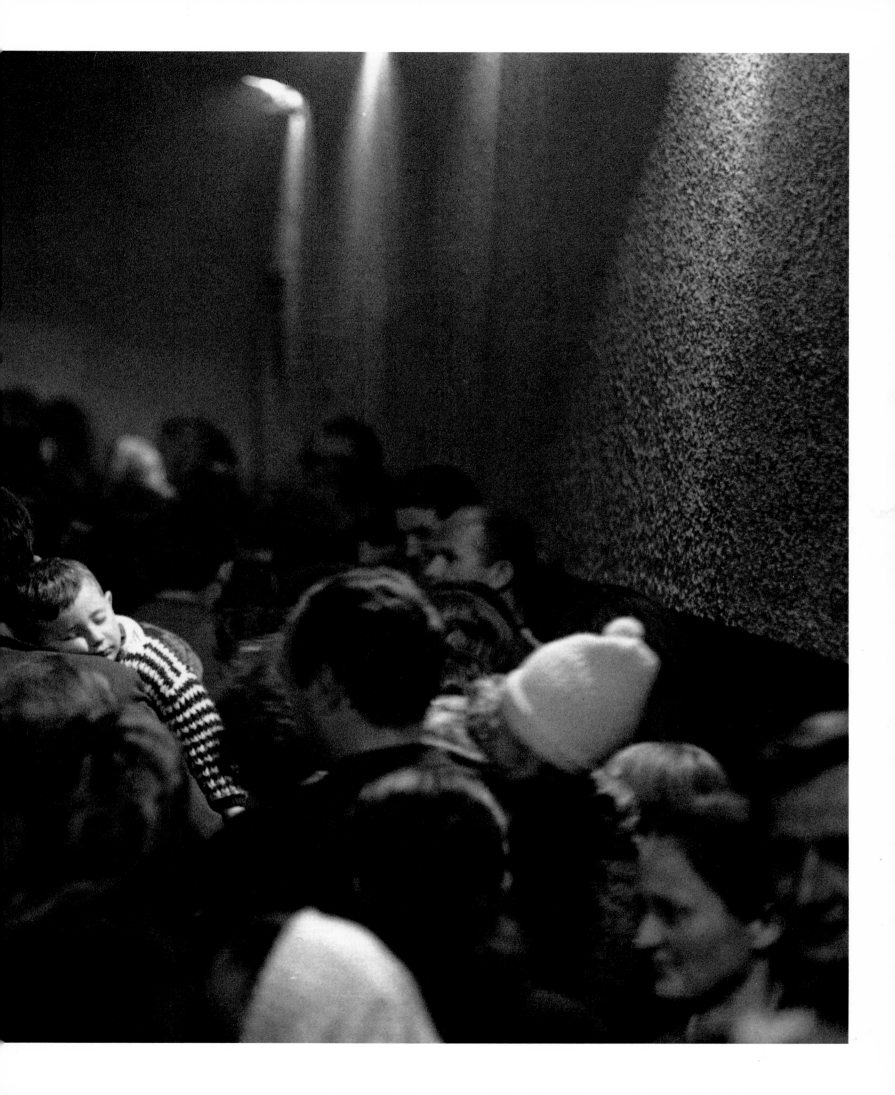

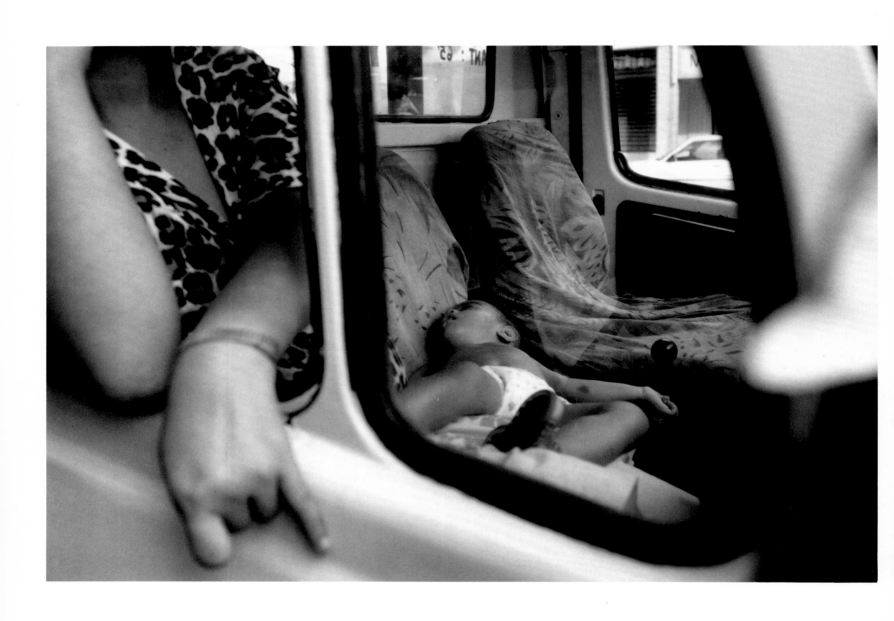

papeete tahiti 1995

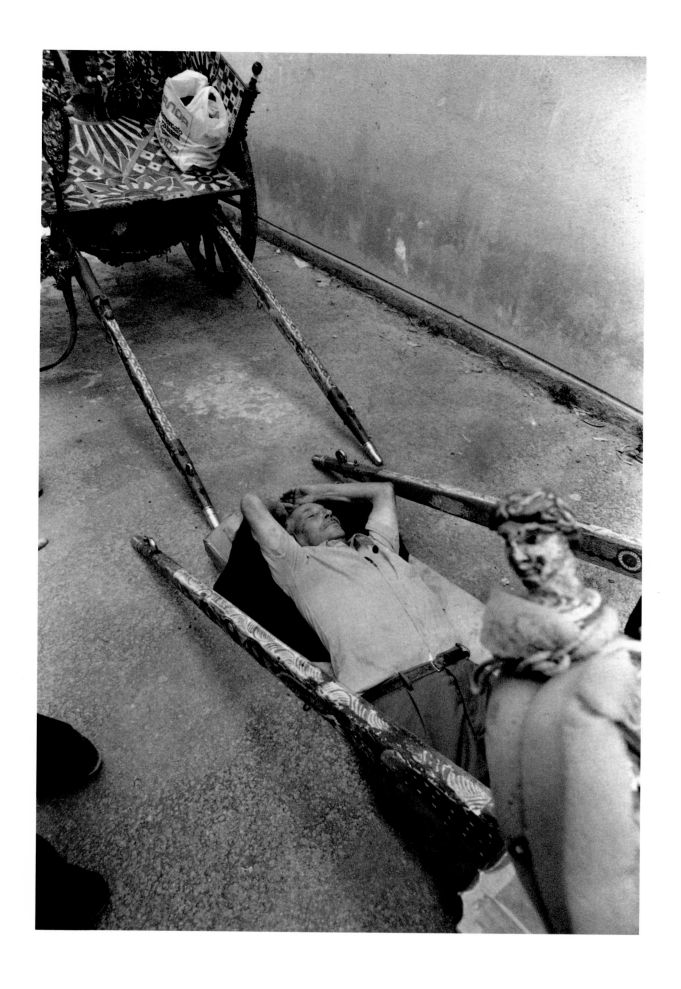

bagheria italy 1980

paris france 1975 >

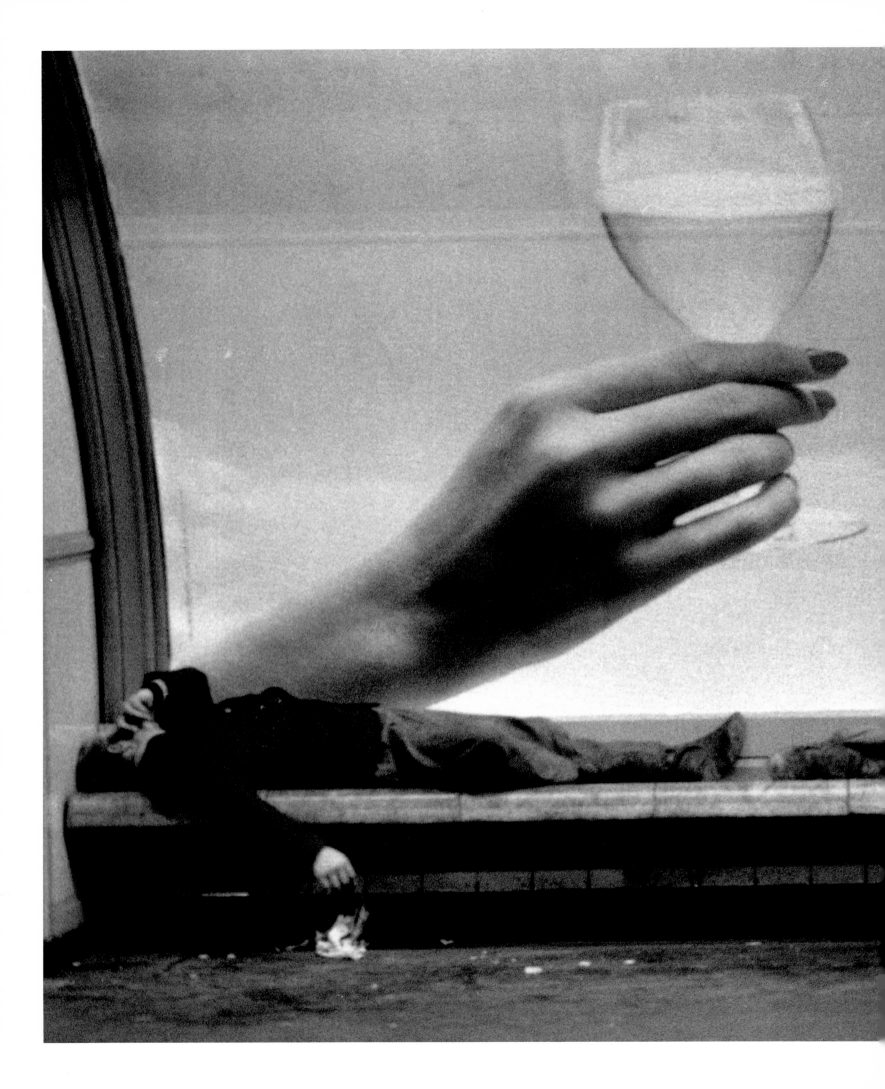

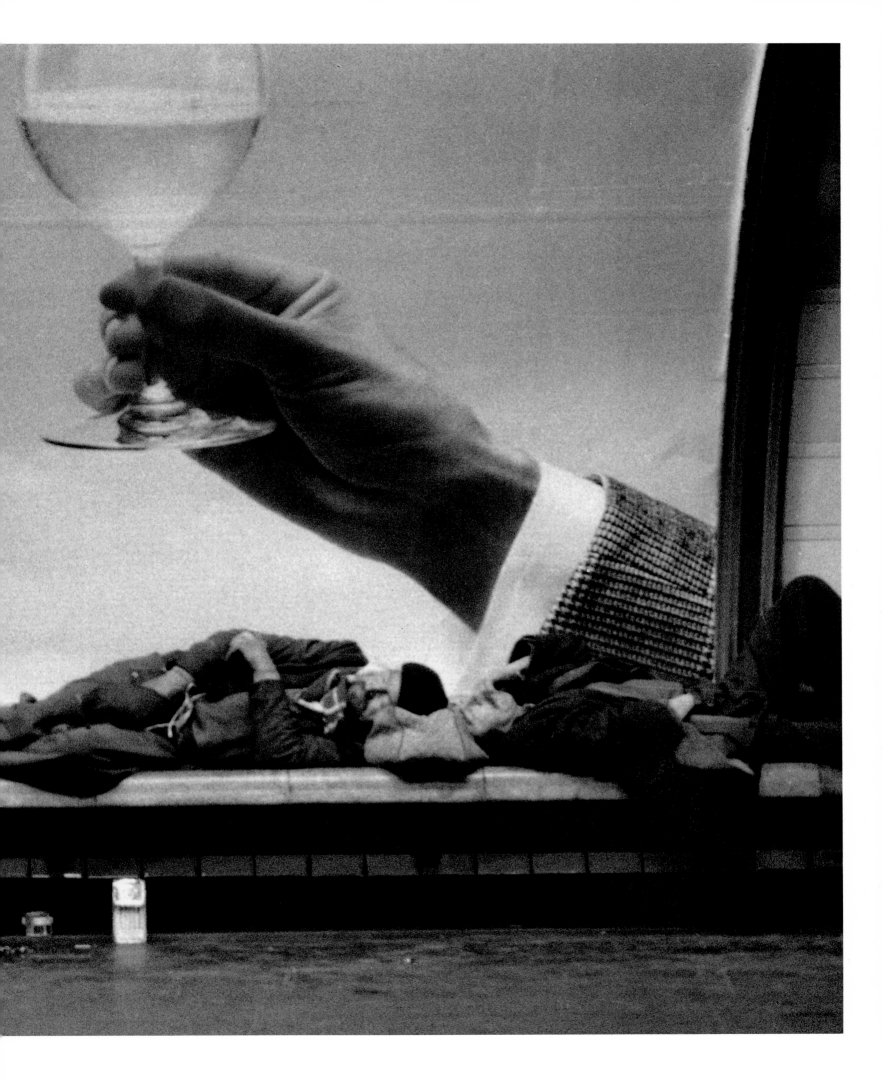

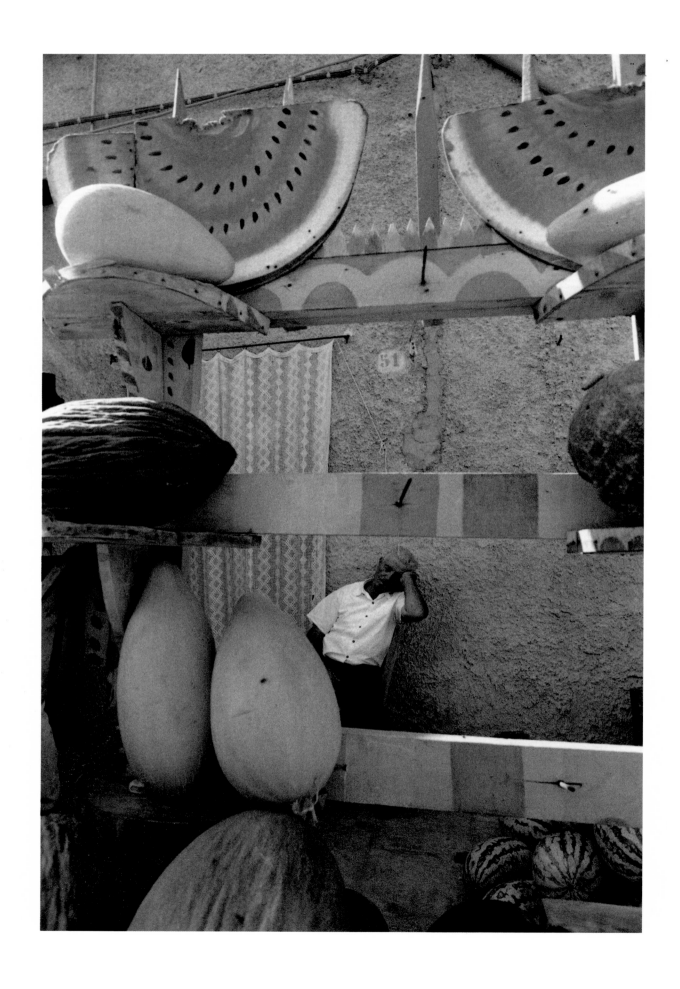

altavilla milicia italy 1971

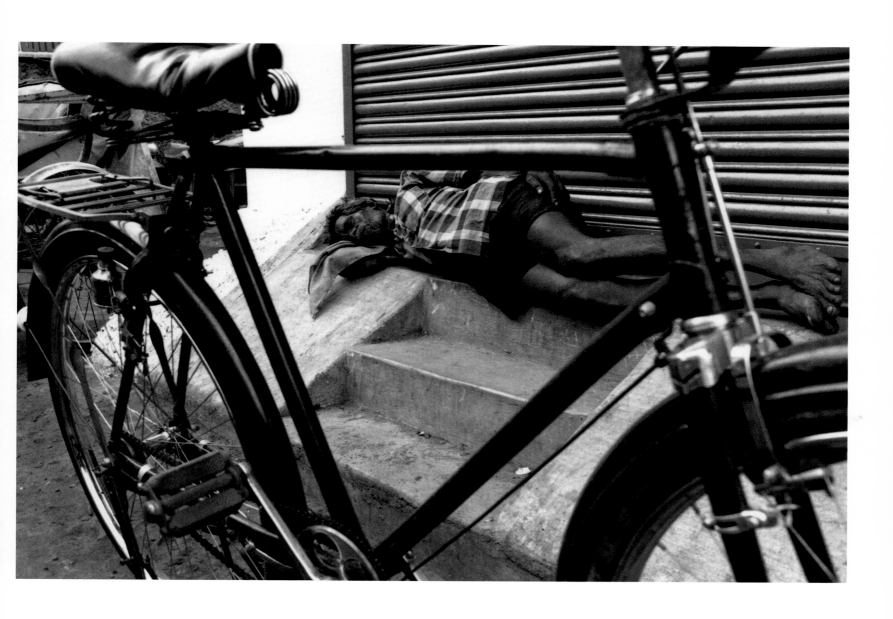

madras india 1989

My friend, dreams are things hard to interpret, hopeless to puzzle
Out, and people find that not all of them end in anything.
There are two gates through which the insubstantial dreams issue.
One pair of gates is made of horn, and one of ivory.
Those of the dreams which issue through the gate of sawn ivory,
These are deceptive dreams, their message is never accomplished.
But those that come into the open through the gates of polished
Horn accomplish the truth for any mortal who sees them.

> *Homer,* Odyssey XIX.560–7, translated by Richmond Lattimore

For life is but a dream whose shapes return.

> *James Thomson,* The City of Dreadful Night, 1

Come, Sleep! Oh Sleep, the certain knot of peace,
The baiting-place of wit, the balm of woe,
The poor man's wealth, the prisoner's release,
The indifferent judge between the high and low.

> *Sir Philip Sidney,* Astrophel and Stella, Sonnet 39

Sleep does for us temporarily what old age does permanently; it
cuts us off from the fulness of the present, and so allows us to drift
back into the past.

> *James Sully*

Sleep, little Baby, sleep;
 The holy Angels love thee,
And guard thy bed and keep
 A Blessed watch above thee.

> *Christina Rossetti,* Holy Innocents

Dreams out of the ivory gate, and visions before midnight.

> *Sir Thomas Browne,* On Dreams

 Zenophile, my tender bloom,
thou sleepest. Oh the guise
of gliding slumber to assume
and enter on thine eyes!

 That thereby might not even he
have unto thee access
who lulls the lids of Zeus, but thee
I only might possess.

> *Meleager*

And all I ask is a merry yarn from a laughing fellow rover,
And a quiet sleep and a sweet dream when the long trick's over.

> *John Masefield,* Sea Fever

Oh, for the time when I shall sleep
Without identity.

> *Emily Brontë,* Oh, for a time …

Up the road, in his shack, the old man was sleeping again.
He was still sleeping on his face and the boy was sitting by him watching him
 The old man was dreaming about the lions.

> *Ernest Hemingway,* The Old Man and the Se

And yet, as angels in some brighter dreams
Call to the soul when man doth sleep,
So some strange thoughts transcend our wonted themes,
And into glory peep.

> *Thomas Vaughan,* Silex Scintillans: They Are All Gone

Lazy, laughing languid Jenny
Fond of a kiss and fond of a guinea
Whose head upon my knee tonight
Rests for a while, as if grown light …

Why, Jenny, you're asleep at last! –
Asleep, poor Jenny, hard and fast, –
So young and soft and tired; so fair,
With chin thus nestled in your hair,
Mouth quiet, eyelids almost blue,
As if some sky of dreams shone through.

 … Let her sleep.
But will it wake her if I heap
These cushions thus beneath her head
Where my knee was? No, – there's your bed
My Jenny, while you dream. And there
I lay among your golden hair
Perhaps the subject of your dreams,
These golden coins.

> *Dante Gabriel Rossetti,* Jenny

Like all pleasures, sleep too becomes, at times, a passion.

> *Anthelme Brillat-Savarin,* The Physiology of Taste

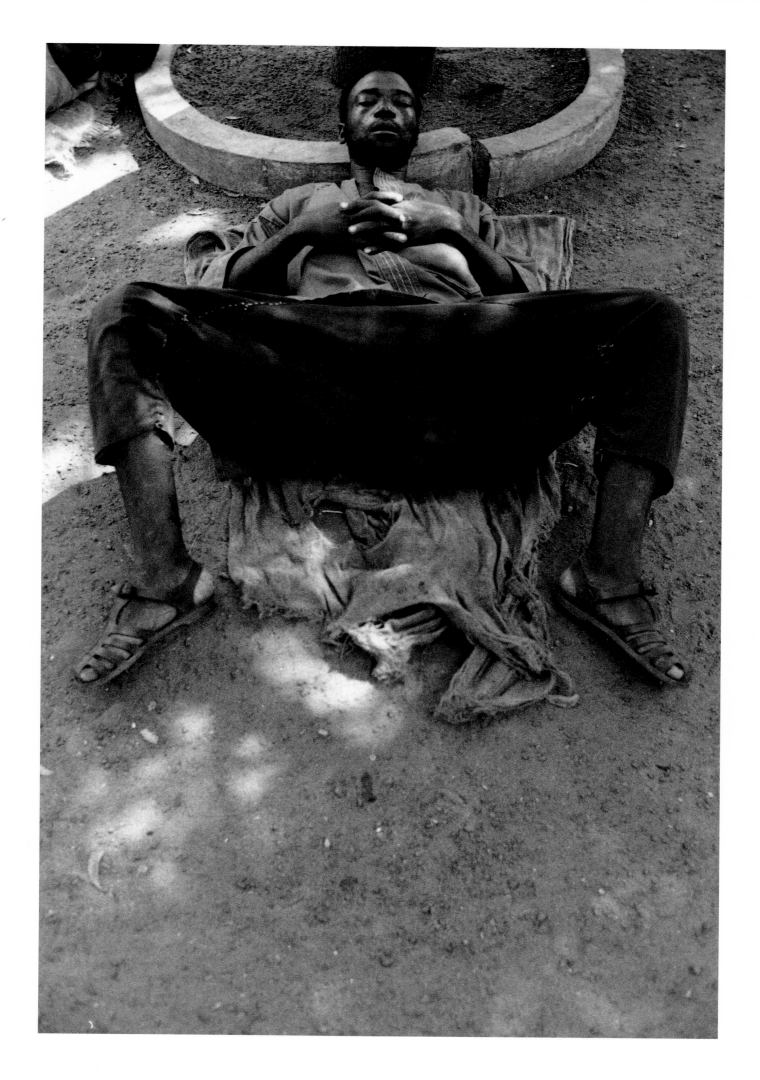

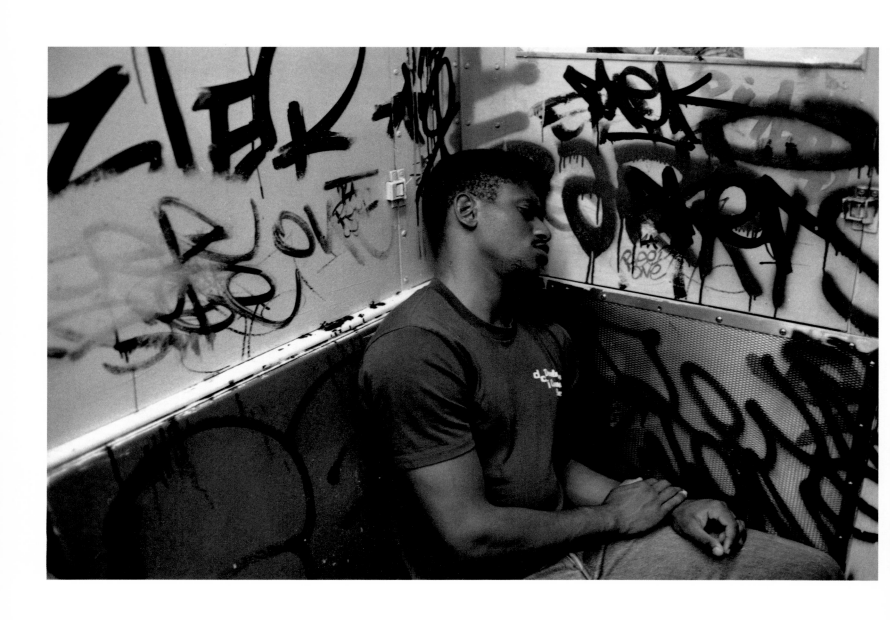

new york united states 1985

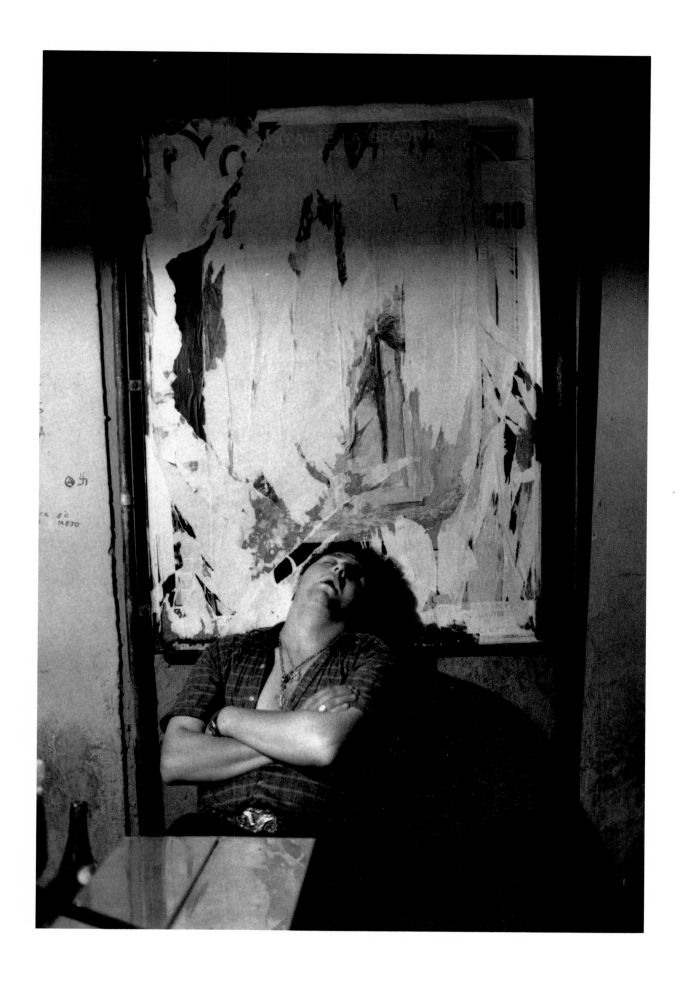

rome italy 1988

milan italy 1984

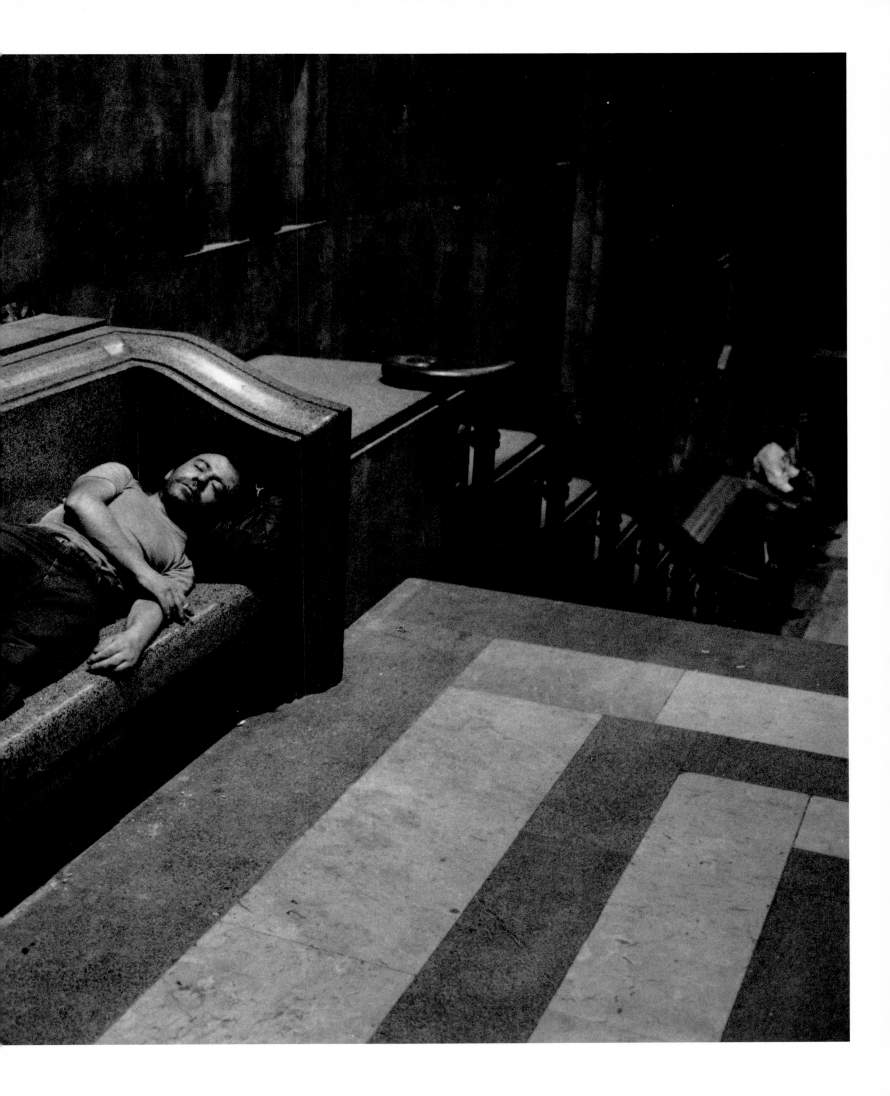

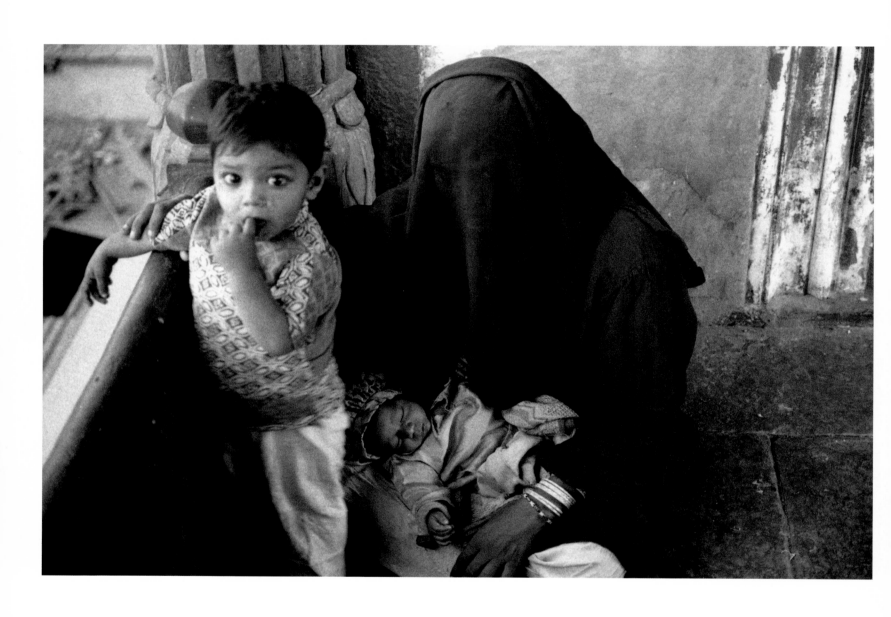

new delhi india 1972

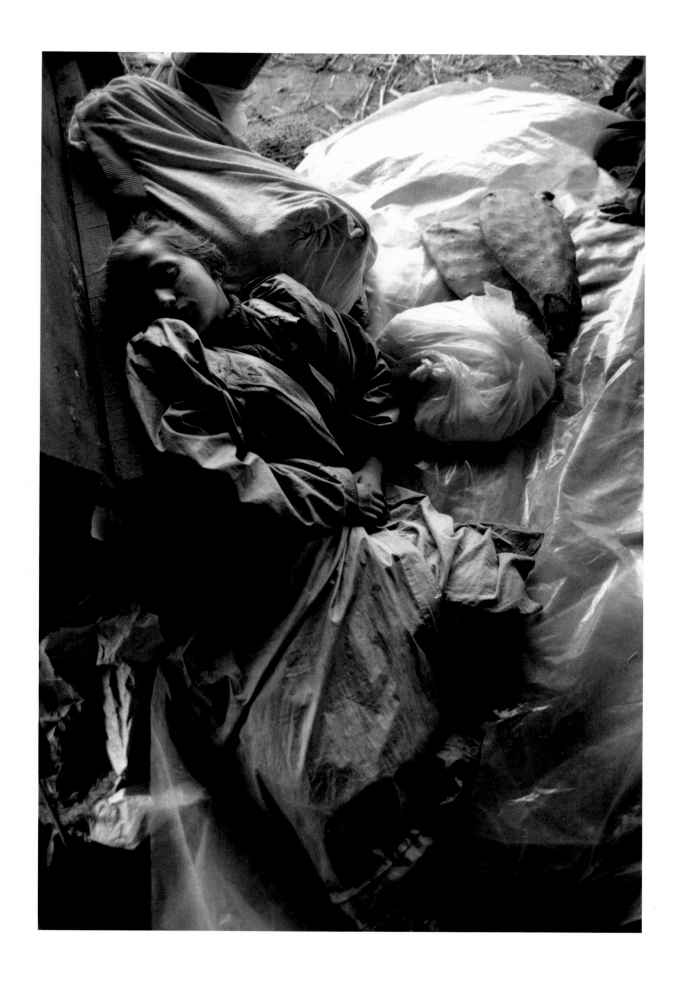

brindisi italy 1991

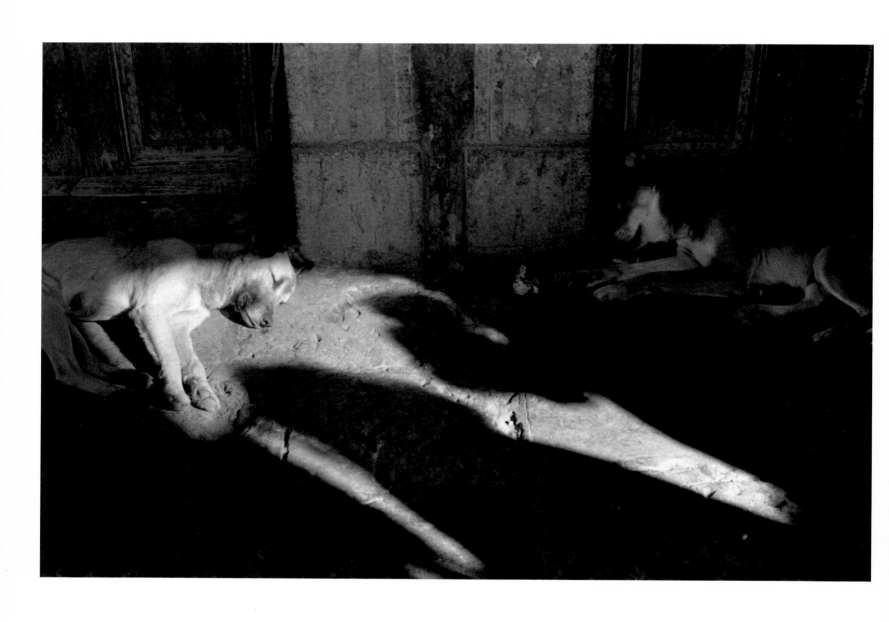

oaxaca mexico 1988

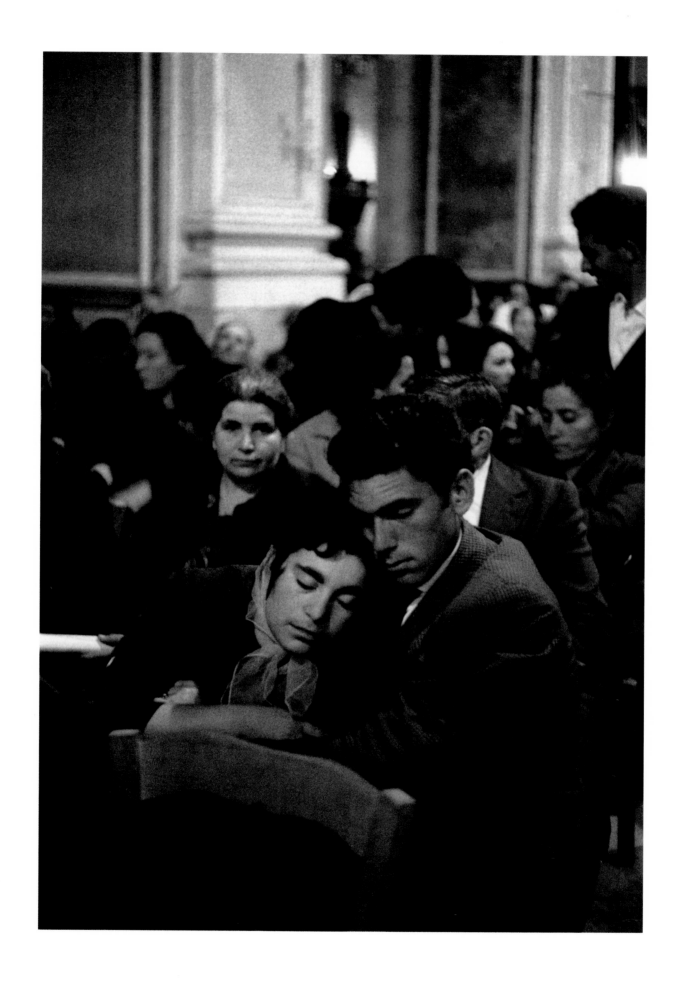

lentini italy 1964

Thou hast been call'd, O Sleep! the friend of Woe,
But 'tis the happy who have called thee so.

Robert Southey, The Curse of Kehama, xv.12

I have lost my sleep,
I vacillate
At a street corner
Like a glow-worm.
Will it die on me
Tonight?

Giuseppe Ungaretti, June

If you can dream – and not make dreams your master.

Rudyard Kipling, If …

He slept with so sweet a sensation that he was
charmed. Then, he regretted having woken up; in
some cases we should never let go of sleep.

Federigo Tozzi, Three Crosses

O sleep, O placid son of the quiet,
Humid, shady night,
Comfort of sad mortals,
Sweet oblivion of the heavy,
Harsh and bitter ills of life.

Giovanni della Casa, O Sleep

Tir'd Nature's sweet restorer, balmy sleep!
He, like the world, his ready visit pays
Where fortune smiles; the wretched he forsakes.

Edward Young, The Complaint: Night Thoughts, i.1–3

Like infant slumbers, pure and light.

John Keble, Evening

But there is in dreams, especially in generous ones,
an impulsive and compromising quality that often
overwhelms even those who would like to confine
them to the harmless limbo of idle fantasy.

Alberto Moravia, The Miser

O Sleep! thou flatterer of happy minds.

William Congreve, Elegy to Sleep

Soldier, rest! thy warfare o'er,
Sleep the sleep that knows not breaking,
Dream of battled fields no more,
days of danger, nights of waking.

Sir Walter Scott, The Lady of the Lake, 1

Sleep is pain's easiest salve, and doth fulfil
All offices of death, except to kill.

John Donne, The Storme: To Mr Christopher Brooke

And now dewy night had reached its midway mark,
and the sailors on their hard rowing benches
relaxed their limbs in quiet rest; when Sleep,
gliding softly from the stars, put the night air aside
and parted the darkness, seeking thee, O Palinurus,
and bringing thee baleful dreams.

Vergil, Aeneid, V.835–40

Beloved, may your sleep be sound
That have found it where you fed.
What were all the world's alarms
To mighty Paris when he found
Sleep upon a golden bed
That first dawn in Helen's arms?

Sleep, beloved, such a sleep
As did that wild Tristram know
When, the potion's work being done,
Roe could run or doe could leap
Under oak and beechen bough,
Roe could leap or doe could run;

Such a sleep and sound as fell
Upon Eurotas' grassy bank
When the holy bird, that there
Accomplished his predestined will,
From the limbs of Leda sank
But not from her protecting care.

William Butler Yeats, Lullaby

(After a night without sleep) I still experience the
same feeling that I had in childhood, the feeling of
superiority over those who had spent the night
sleeping.

Valéry Larbaud, A.O. Barnabooth: Diary

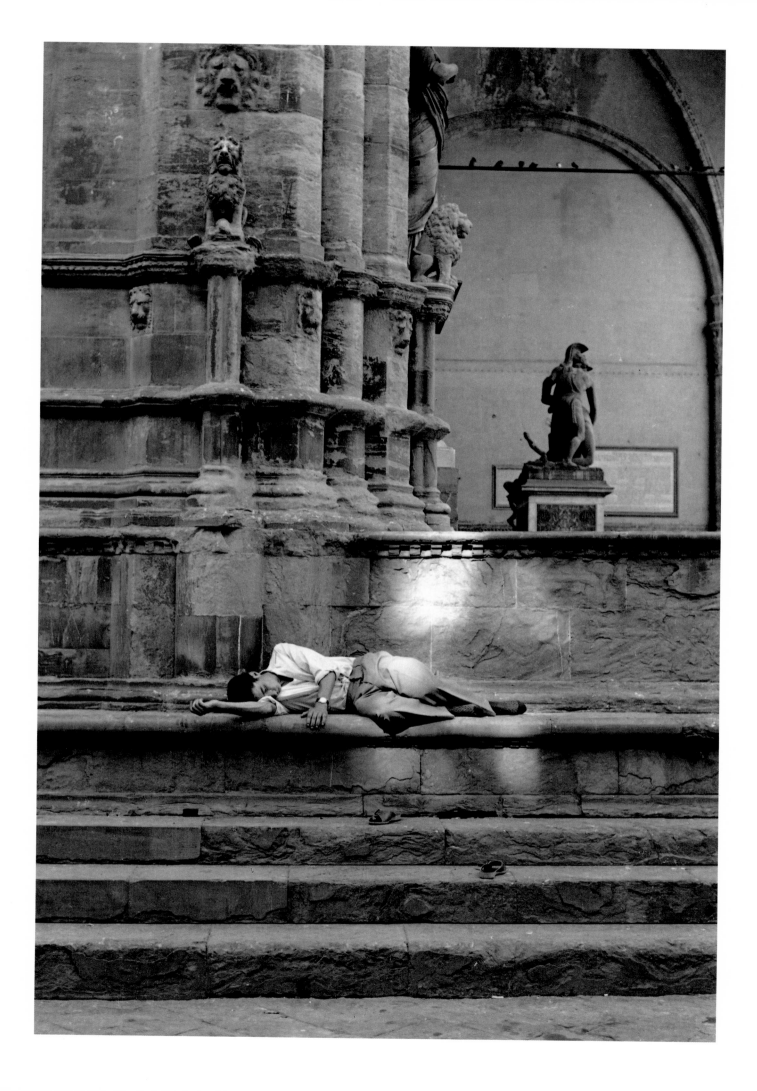

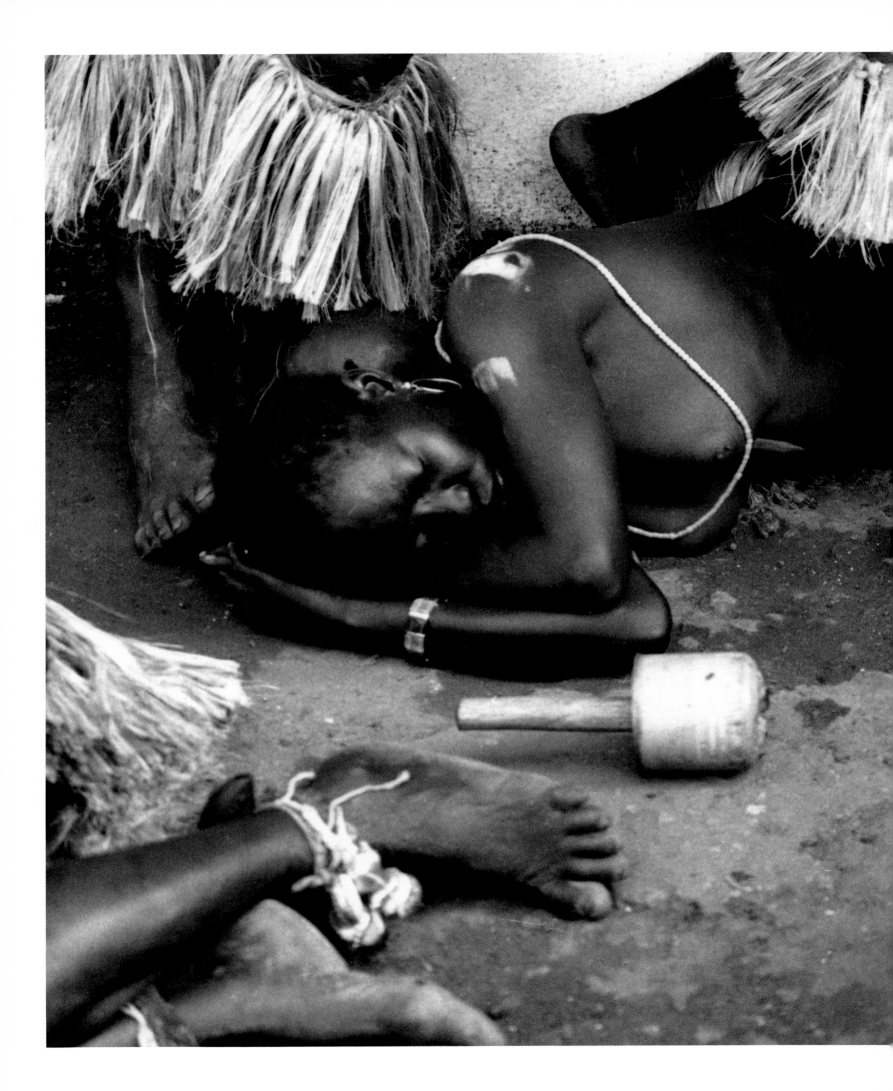

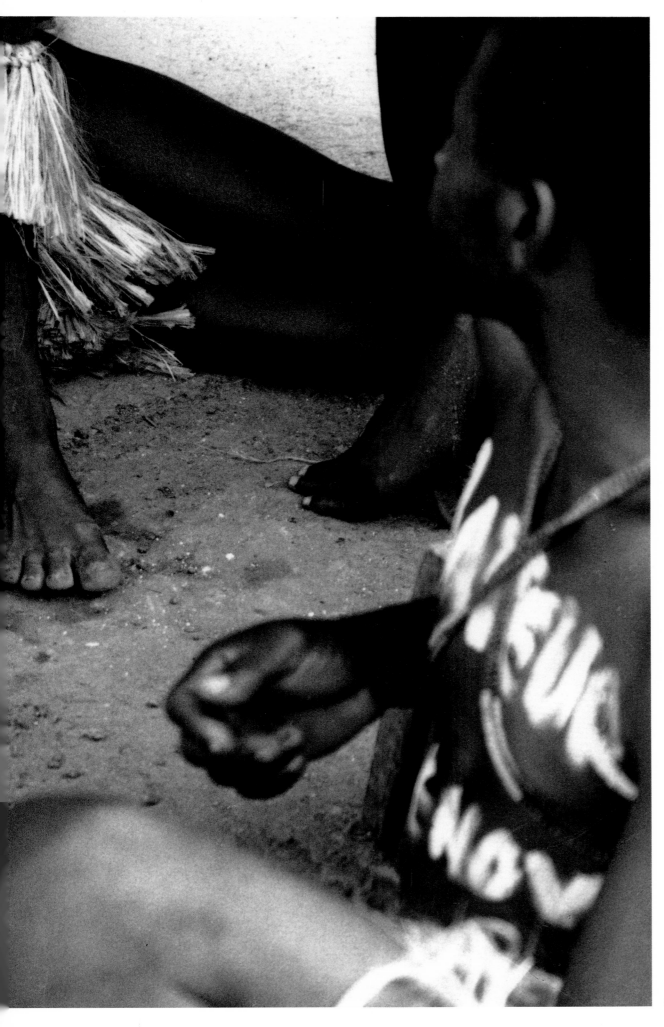

bangui
central african republic 1977

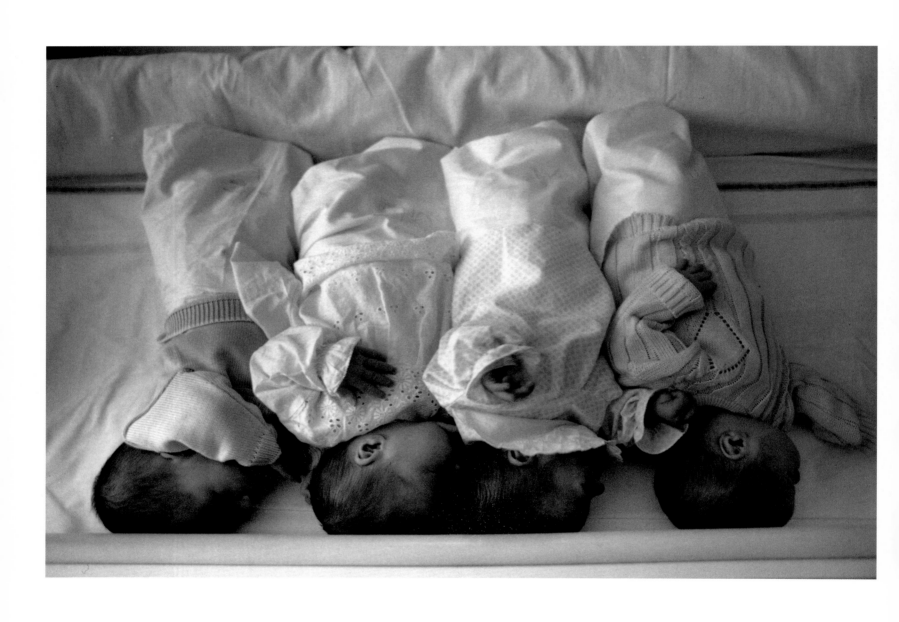

pavia italy 1993

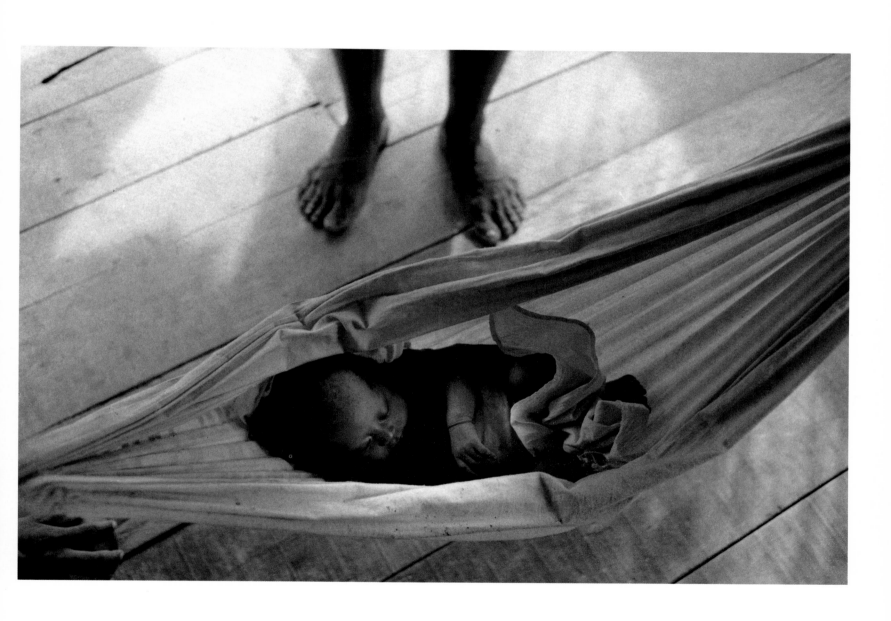

leticia colombia 1987

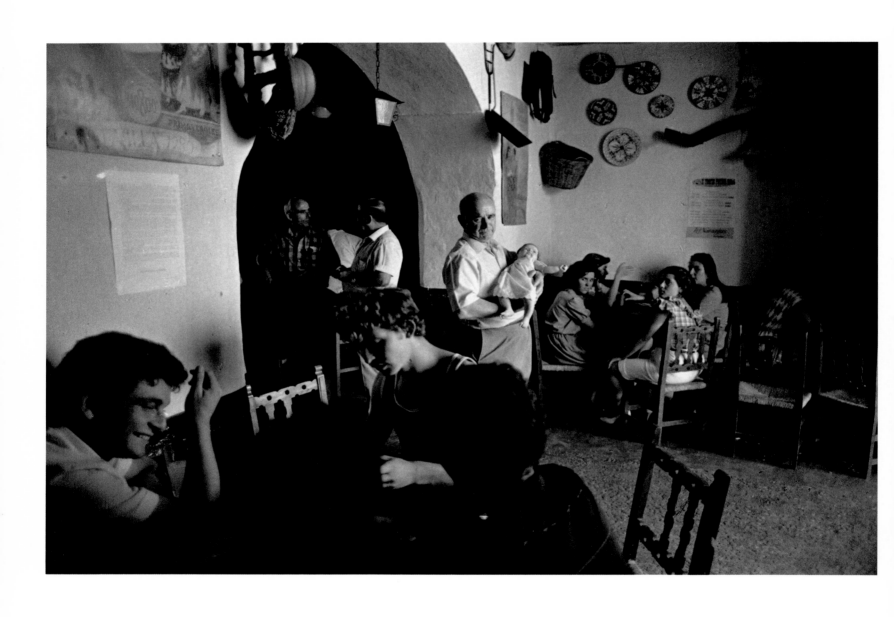

écija spain 1983

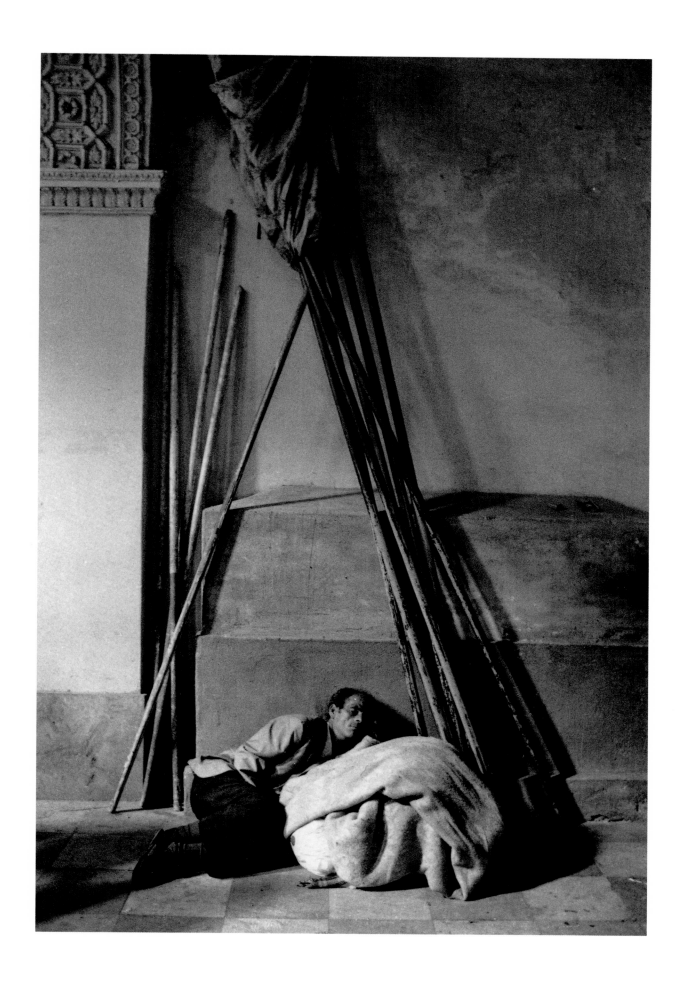

polsi italy 1971

bali indonesia 1989

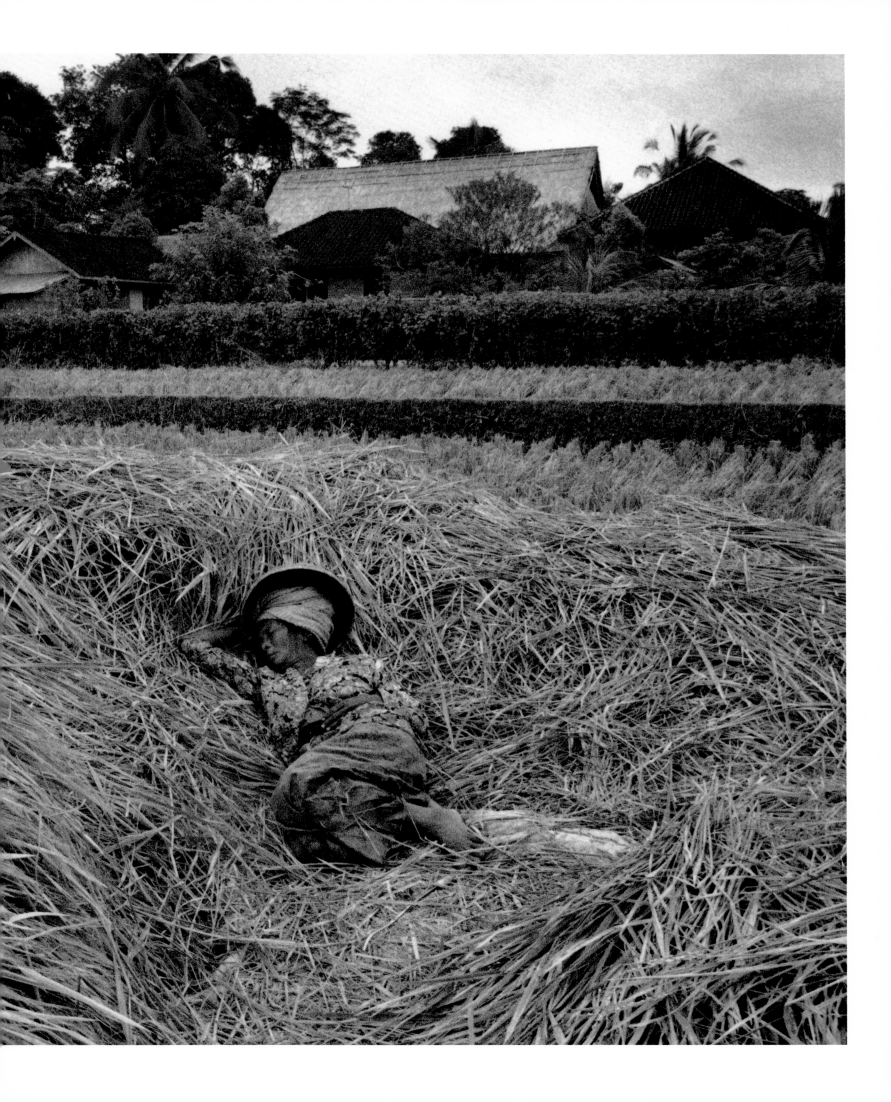

Death will come when thou art dead,
 Soon, too soon –
Sleep will come when thou art fled;
Of neither would I ask the boon
I ask of thee, beloved Night –
Swift be thine approaching flight,
 Come soon, soon!

Percy Bysshe Shelley, To Night

It was darkest night when I fell asleep at last. In
my subconscious a fine dust of sensations too
vague to call dreams fluctuated – so vague indeed
that I could not even be sure whether they were
sensations of a visual, acoustic, or some other kind.

Paola Capriolo, The Double Kingdom

Now I lay me down to sleep;
I pray the Lord my soul to keep.
If I should die before I wake,
I pray the Lord my soul to take.

Anon., New England Primer, 1781

… the sleep which, often,
Knows the news before the event occurs.

Dante, Purgatorio, XXVII.92–3

The three mastiffs, crouching under the tree
around him, gazed at him with humid, intent eyes,
wagging their tails lovingly. But their master
looked at them askance, annoyed that they had
seen him asleep.

Luigi Pirandello, The Old and the Young

I will pour out my spirit upon all flesh; and your
sons and daughters shall prophesy, your old men
shall dream dreams, and your young men shall see
visions.

Joel 2:28

Now she wants to rest; she wants to sleep.
How beautiful you'll be in your sleep,
Woman!

Alfred Mombert, Lullaby

… Then from anguish
Wishing to cry out, and trembling,
Eyes full of doleful tears,
I tore myself from sleep.
But in my mind remained her vivid image
And in the uncertain ray of sunshine
I believed I saw her still.

Giacomo Leopardi, The Dream

Here we are all, by day; by night w' are hurl'd
By dreames, each one, into a sev'rall world.

Robert Herrick, Dreames

In sleep, as in madness, there is the same tyranny
of the imagination over the judgement … single
images meet, and jostle, and unite together,
without any power to compare them with others,
with which they are connected in the world of
reality … There is, however, a sort of profundity in
sleep; and it may usefully be consulted as an oracle
in this way. It might be said, that the voluntary
power is suspended, and things come upon us as
unexpected revelations, which we keep out of our
thoughts at other times … We are not hypocrites in
our sleep.

William Hazlitt

How we learn to die
In you, sleep!
With such consummate beauty
You take us – through gardens that
Appear more familiar every time –
To become acquainted with the shadows!

Juan Ramón Jiménez, How we Learn to Die

I like to sleep, it is true;
Happily I take to my bed the Night,
This black creature.

Victor Hugo, Pebbles

Our poor vast petty life is one dark maze of dreams.

James Thomson, Insomnia

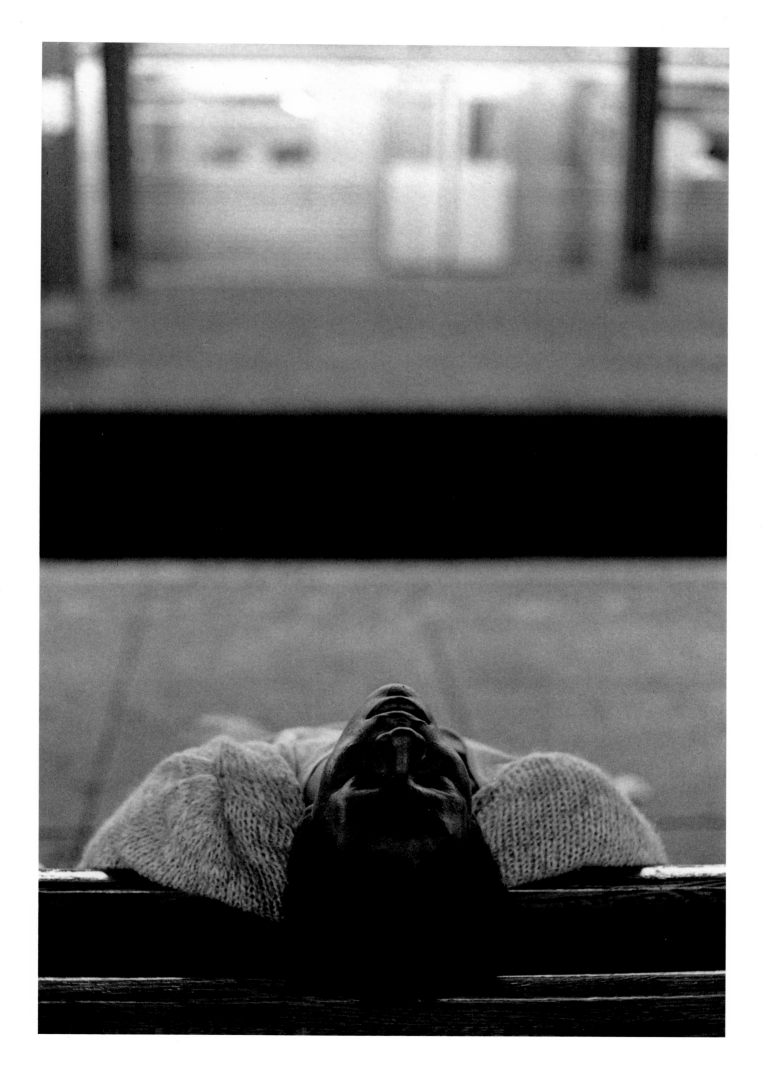

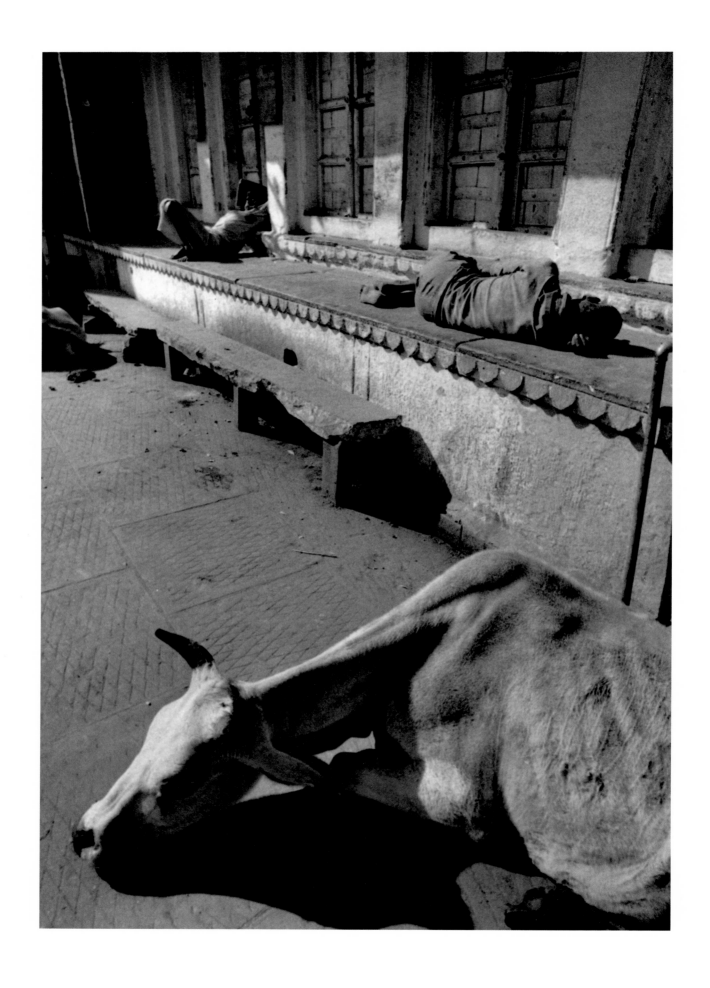

benares india 1972

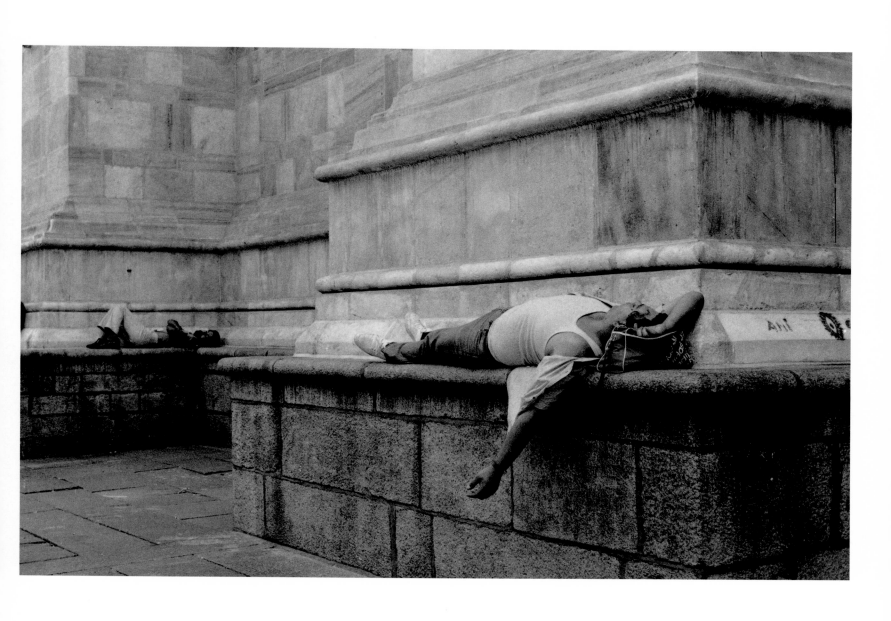

milan italy 1982

new york united states 1991

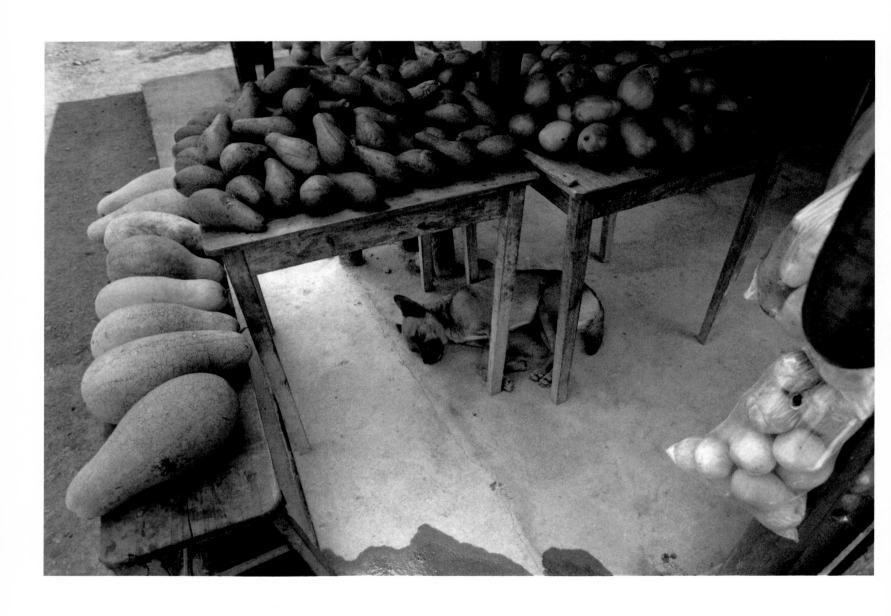

colombia 1987

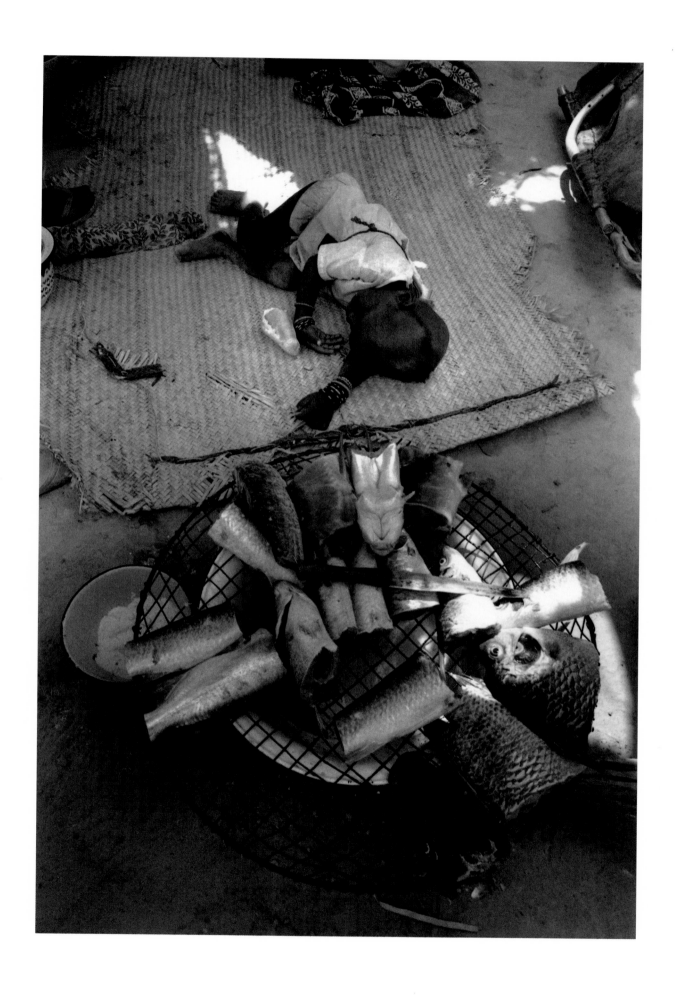

youvarou mali 1993

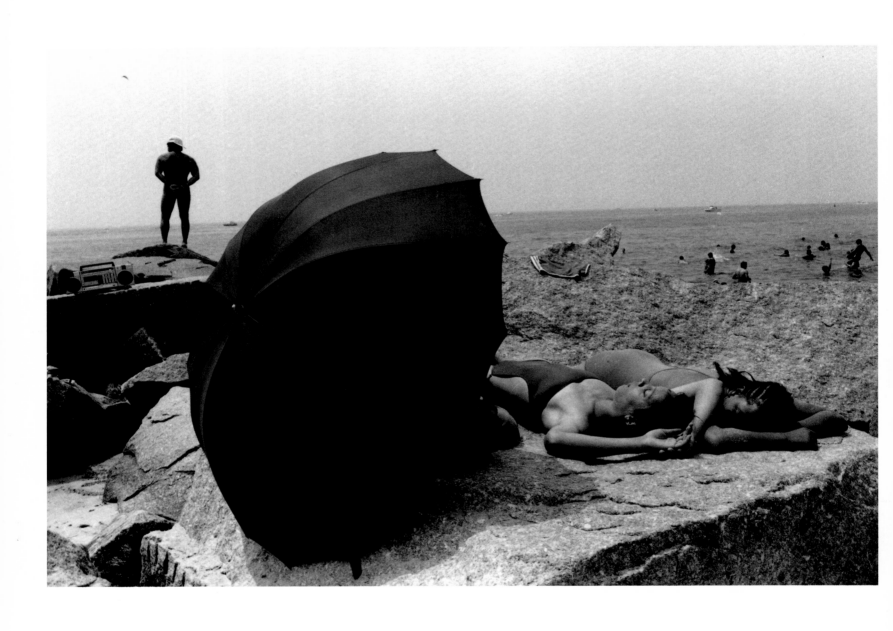

new york united states 1985

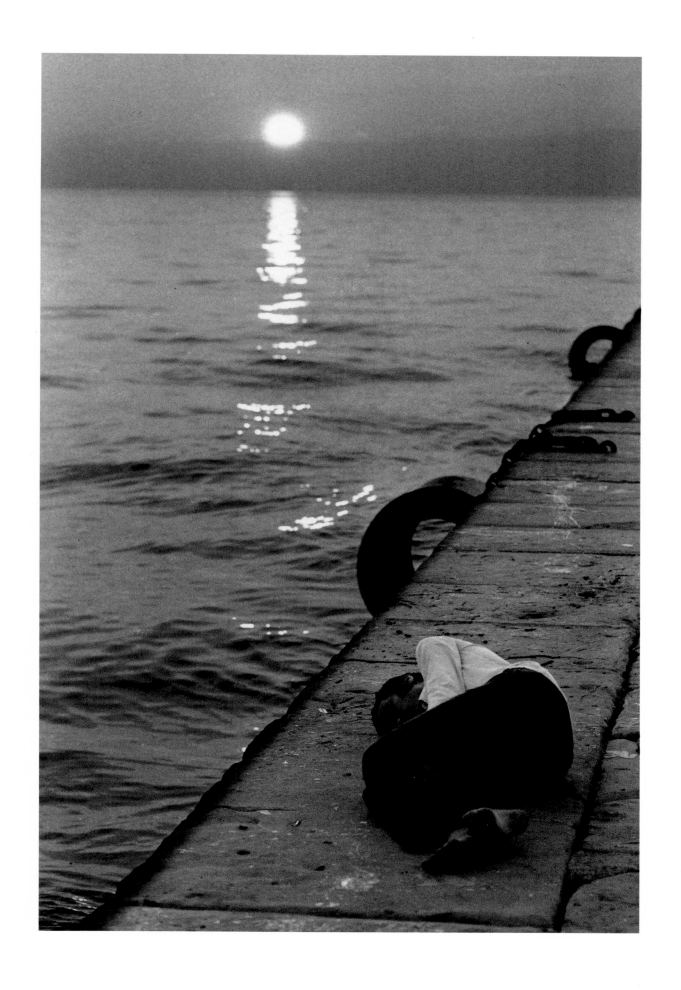

trieste italy 1973

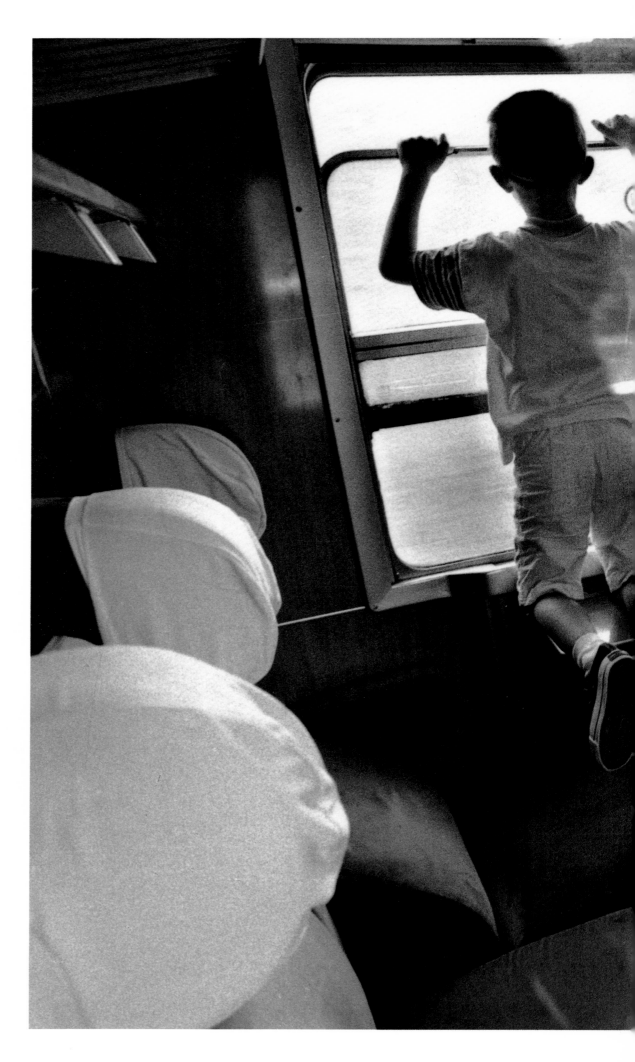

brindisi-rome train italy 1991

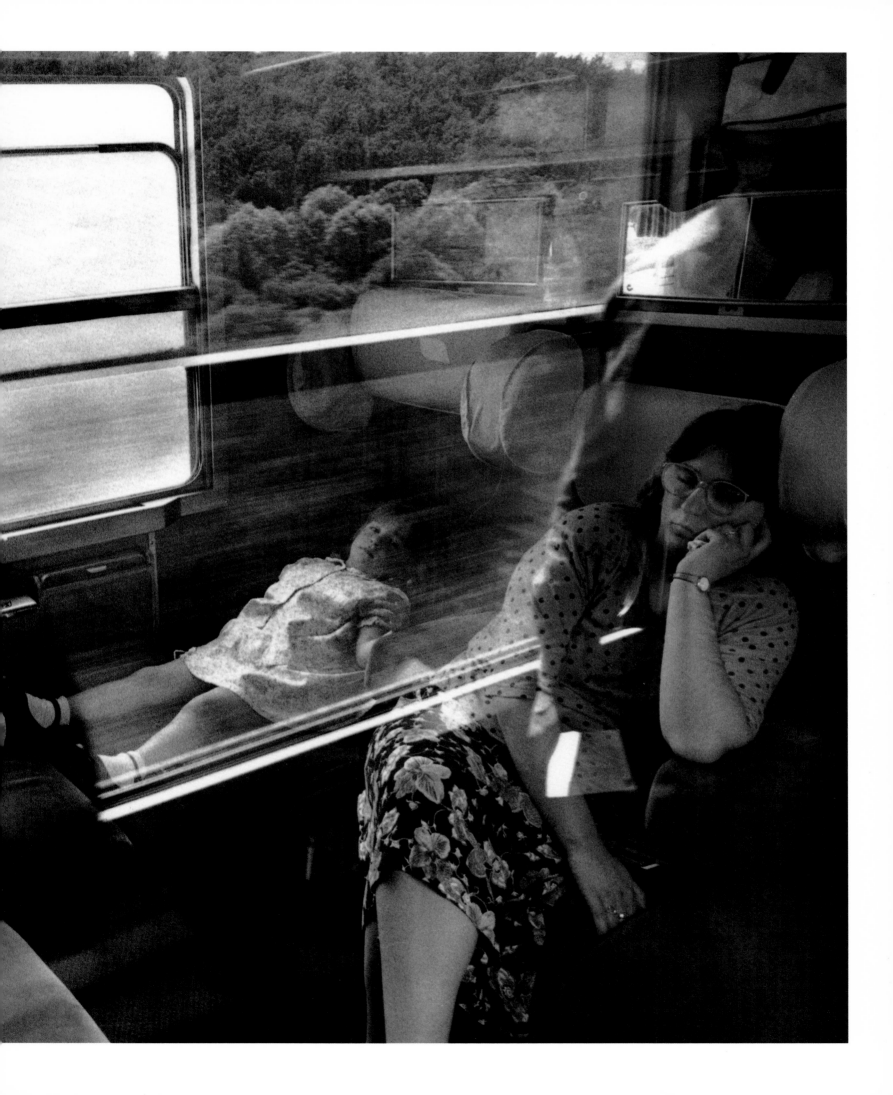

The woods are lovely, dark and deep,
But I have promises to keep,
And miles to go before I sleep,
And miles to go before I sleep.
Robert Frost, Stopping by Woods on a Snowy Evening

A traveller must take to the road,
And a child must sleep peacefully.
Nazım Hikmet, Fellow Prisoners

He slept with his face against his folded arm. The woman looked at him and thought how lightly and easily the young bear their fatigue, and yet how heavily they sleep. As if she herself were the giver of that rest, she thought, and almost said: 'Sleep, Sleep.'
Corrado Alvaro, Innocence

We are the music makers,
 We are the dreamers of dreams,
Wandering by lone sea-breakers,
 And sitting by desolate streams.
Arthur William Edgar O'Shaughnessy,
Ode: 'We are the Music Makers'

We were very young. I think I never slept that year.
But I had a friend who slept even less …
Cesare Pavese, The Devil in the Hills

I love life, but I prefer sleep, not because it brings oblivion, but because it brings dreams.
André Gide, Diary

A dreamer of dreams.
Deuteronomy 13:1

Dreams and the light imaginings of men,
And all that faith creates or love desires,
Terrible, strange, sublime and beauteous shapes.
Percy Bysshe Shelley,
Prometheus Unbound, i.200–2

In all of us, even in good men, there is a lawless wild-beast nature, which peers out in sleep.
Plato, Republic

Sleep, let me sleep, for I am sick of care;
Sleep, let me sleep, for my pain wearies me.
Shut out the light; thicken the heavy air
With drowsy incense; let a distant stream
Of music lull me, languid as a dream,
Soft as the whisper of a summer sea.
Christina Rossetti, Looking Forward

Then, when sleep has fettered our limbs in pleasing repose and the entire body lies in total rest, we nonetheless seem to ourselves to be awake and to be moving our limbs, and in the blind blackness of night we think we see the sun and the light of day, we think we can exchange our narrow room for sky, sea, rivers, mountains, we seem to be crossing plains on foot and hearing sounds when the stern silence of night is firmly entrenched all around, we seem to be uttering words when we are silent.
Lucretius, De Rerum Natura, IV.453–61

'On a green and shady bank, profuse of flowers,
Pensive I sat me down: there gentle sleep
First found me, and with soft oppression seized
My drowsy sense, untroubled, though I thought
I then was passing to my former state,
Insensible, and forthwith to dissolve:
When suddenly stood at my head a dream,
Whose inward apparition gently moved
My fancy to believe I yet had being,
And lived.'
John Milton, Paradise Lost, VIII.285–94

Blessings on him who invented sleep, the mantle that covers all human thoughts, the food that appeases hunger, the drink that quenches thirst, the fire that warms cold, the cold that moderates heat, and, lastly, the general coin that purchases all things, the balance and weight that equals the shepherd with the King, and the simple with the wise.
Miguel de Cervantes, Don Quixote, part ii, ch. 68

At night you sleep;
I am an insomniac.
I watch you sleep;
This makes me suffer.
Jacques Prévert, When you Sleep

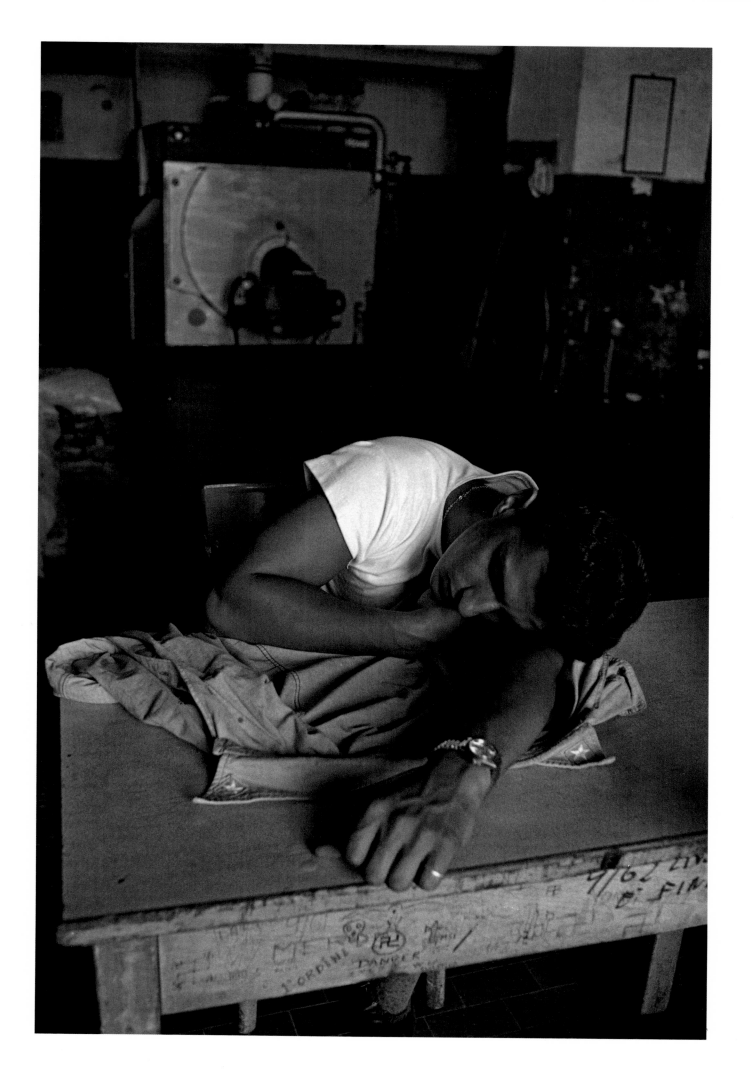

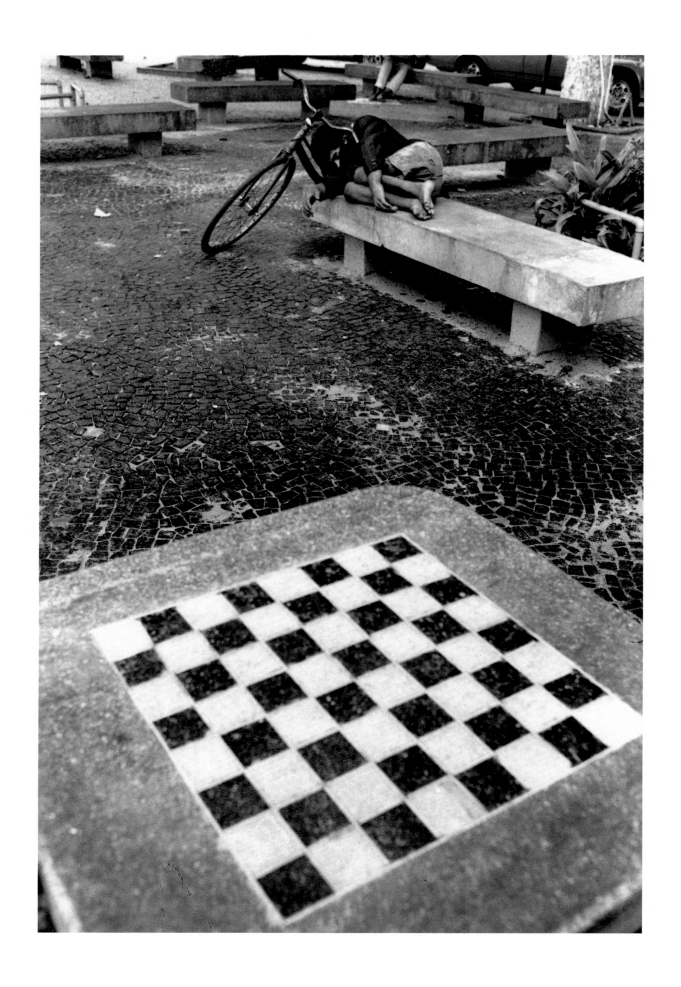

rio de janeiro brazil 1986

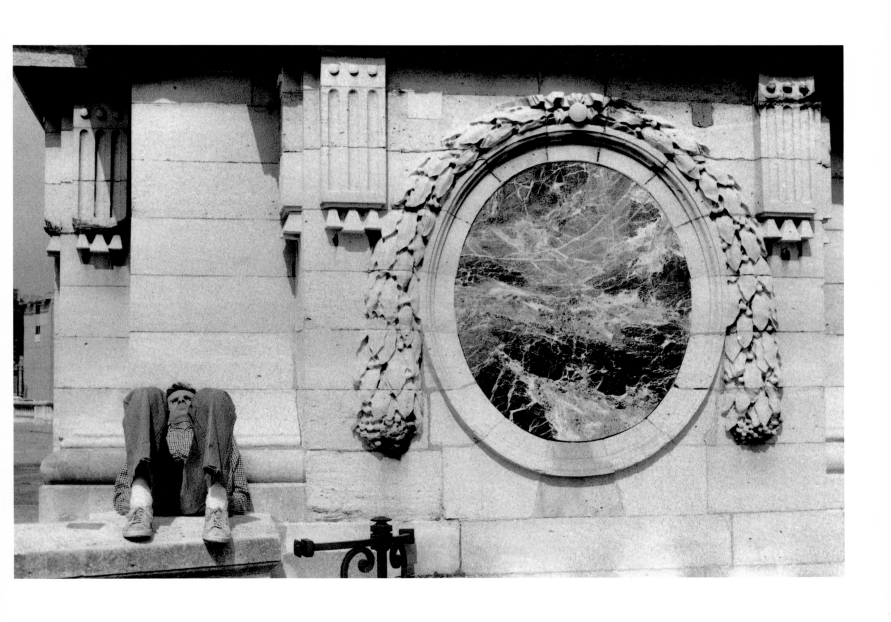

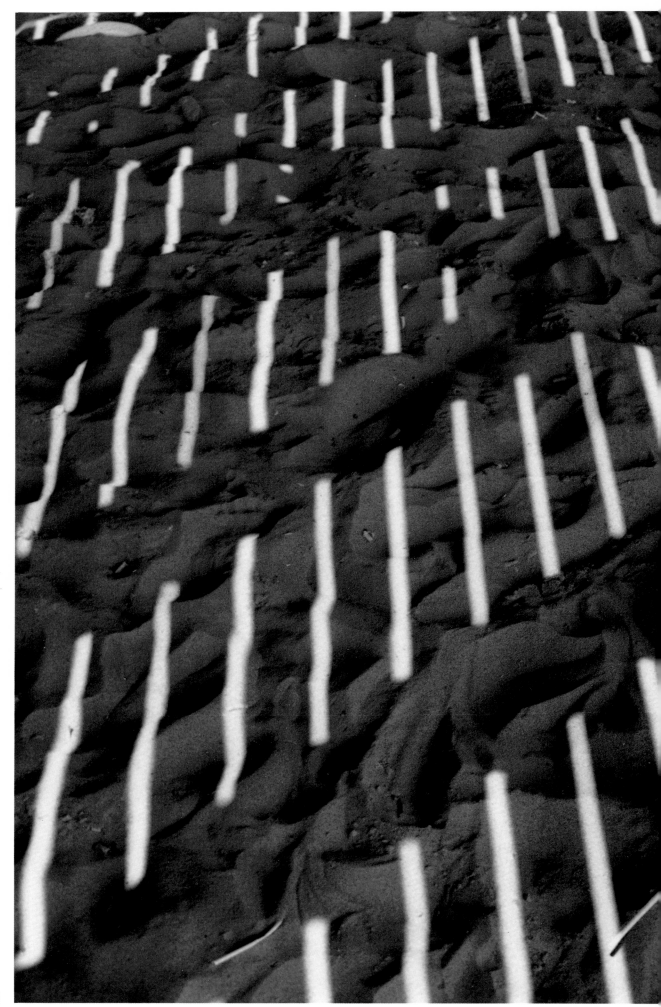

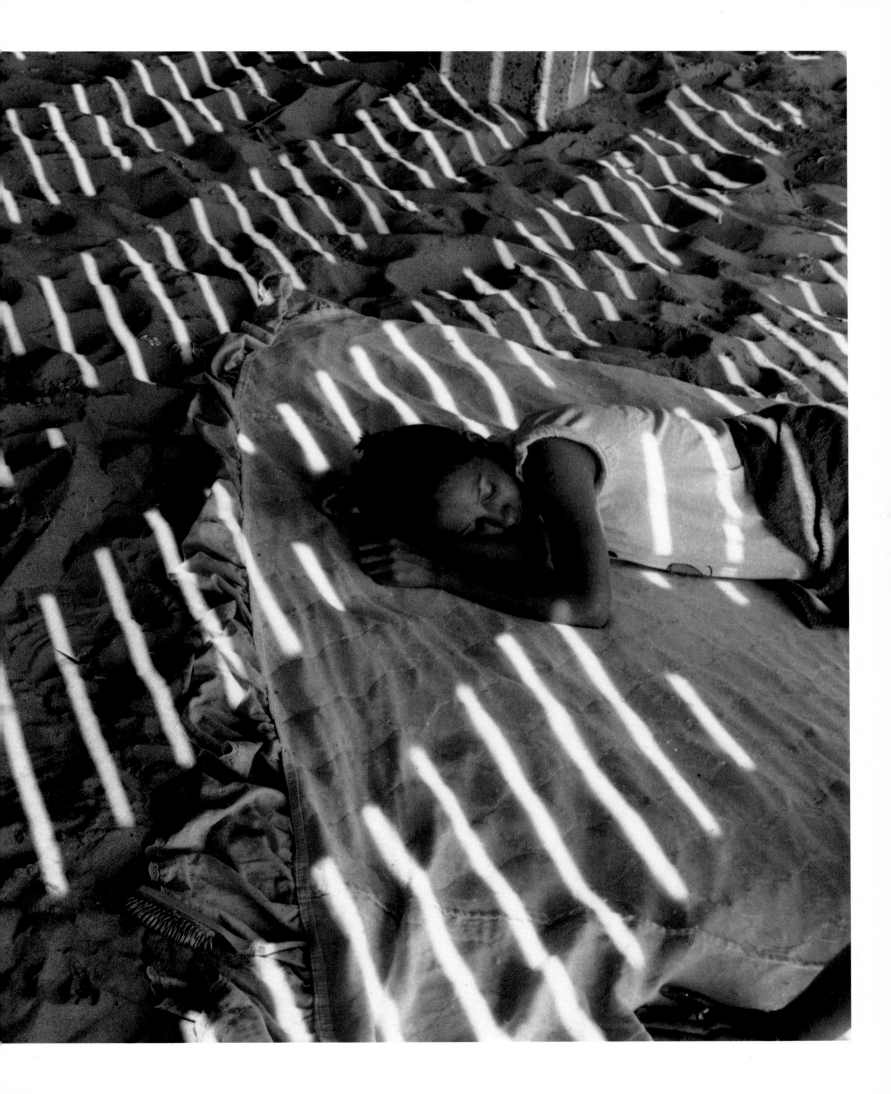

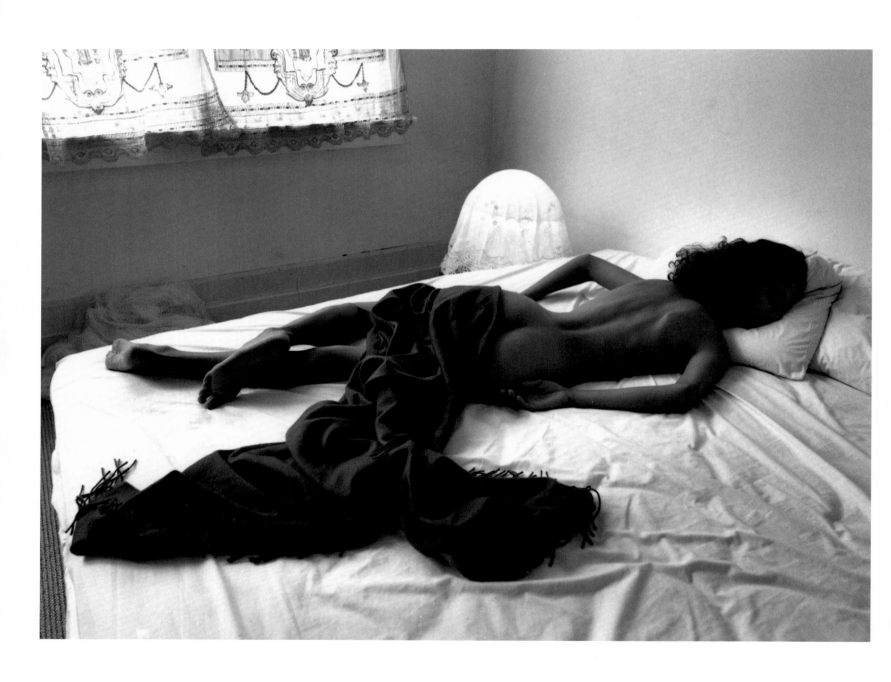

amsterdam netherlands 1990

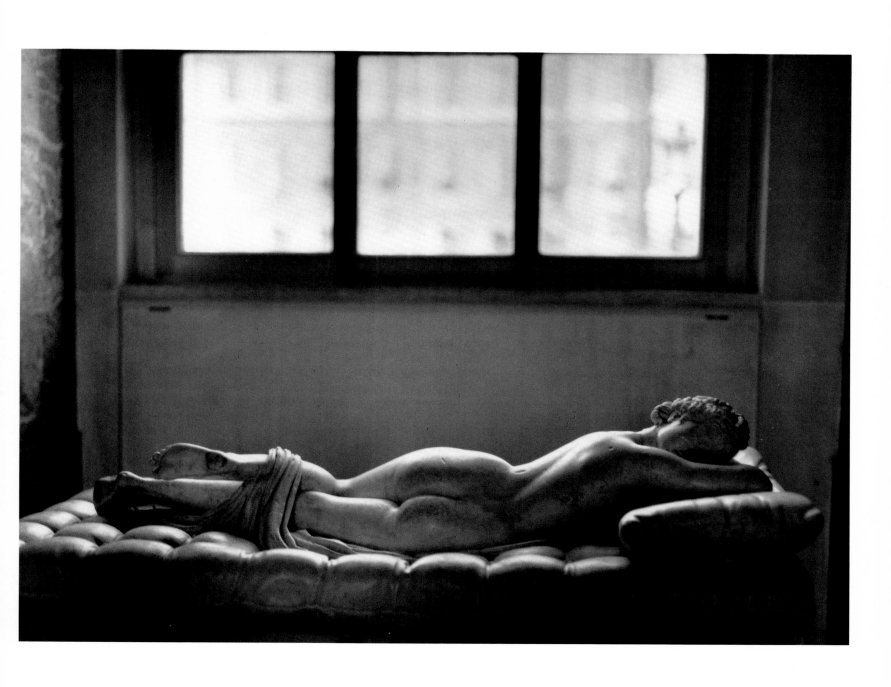

paris france 1977

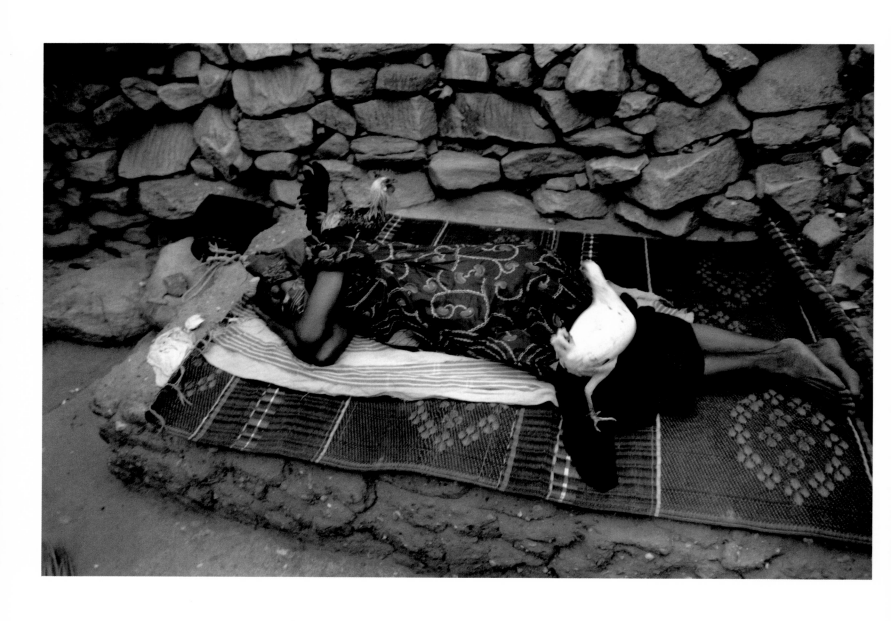

djenne mali 1993

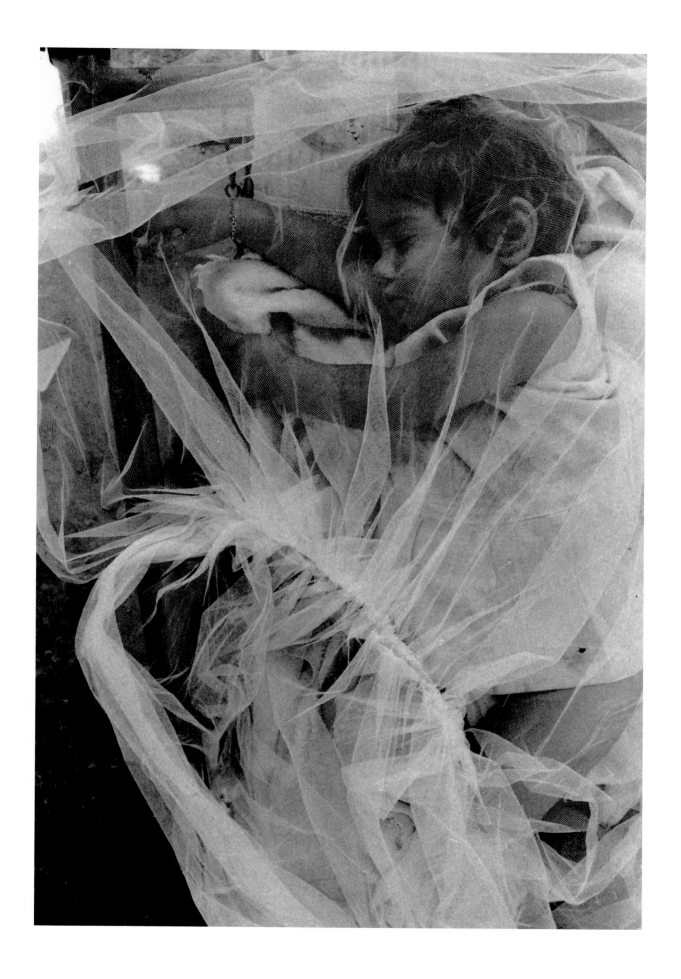

reggio calabria italy 1970

If it were possible to judge depth of sleep, it could be said with justice that Pablo, whose culpable action was responsible for the fire, slept even more soundly than his two friends. But since there is no gauge, it can only be said that he slept very, very soundly.

John Steinbeck, Tortilla Flat

Sleep endures for ever
… the silent bringer
Of endless secrets.

Novalis, Hymn to Night

Dreams are truly not of the future, but the futile semblance of our hopes; Images of the day spoilt and corrupted by the shadow of the night.

Giambattista Guarini, The Faithful Shepherd

She sleeps a tranquil sleep and does not even dream that she will never see me again.

Johann Wolfgang Von Goethe,
The Sorrows of the Young Werther

O magic sleep! O comfortable bird,
That broodest o'er the troubled sea of the mind,
Till it is hushed and smooth!

John Keats, Endymion, i.453–5

We were nearing the last houses,
I put my hands on her breasts;
They were asleep. In the palms of my hands
They bloomed like hyacinths.

Federico García Lorca, She was Married

Oh Sleep! O gentle Sleep!
Nature's soft nurse, how have I frighted thee,
That thou no more will weight my eyelids down
And steep my senses in forgetfulness.

William Shakespeare, King Henry IV, Part II, III.i.5–8

Dreams of the summer night!
 Tell her, her lover keeps
Watch! while in slumbers light
 She sleeps!

Henry Wadsworth Longfellow, The Spanish Student, I.iii

I am tired of tears and laughter,
 And men that laugh and weep;
Of what may come hereafter
 For men that sow and reap:
I am weary of days and hours,
Blown buds of barren flowers,
Desires and dreams and powers
 And everything but sleep.

Algernon Charles Swinburne, The Garden of Proserpine

… What is a man,
If his chief good and market of his time
Be but to sleep and feed? a beast, no more.

William Shakespeare, Hamlet IV.iv.33–5

My sweetest Lesbia let us live and love,
And though the sager sort our deeds reprove,
Let us not weight them: Heaven's great lamps do dive
Into their west, and straight again revive,
But soon as once set is our little night,
Then we must sleep one ever-during night.

Thomas Campion, A Book of Airs, i, translated from
a poem by Catullus

The dream is a protection against the regularity and the routine of life. It is the release of our much-restricted fantasy, it produces a kaleidoscope of all the pictures of life, and it interrupts, with its happy childishness, our adult seriousness.

Novalis

Sleep is truly, as they say, akin to death.

Petrarch, Rime sparse

Nobody needs less sleep than myself, and for me sleep is like a farce. When we have visitors at home, I invite each one to stay for the night, and when they are all asleep, I watch them for a while. Nothing is uglier than this butchered humanity. I avoid it.

Marcel Jouhandeau, Abjection

The face of a sleeping man reveals many things that are hidden in that of a man who is awake.

Arturo Graf, Ecce Homo

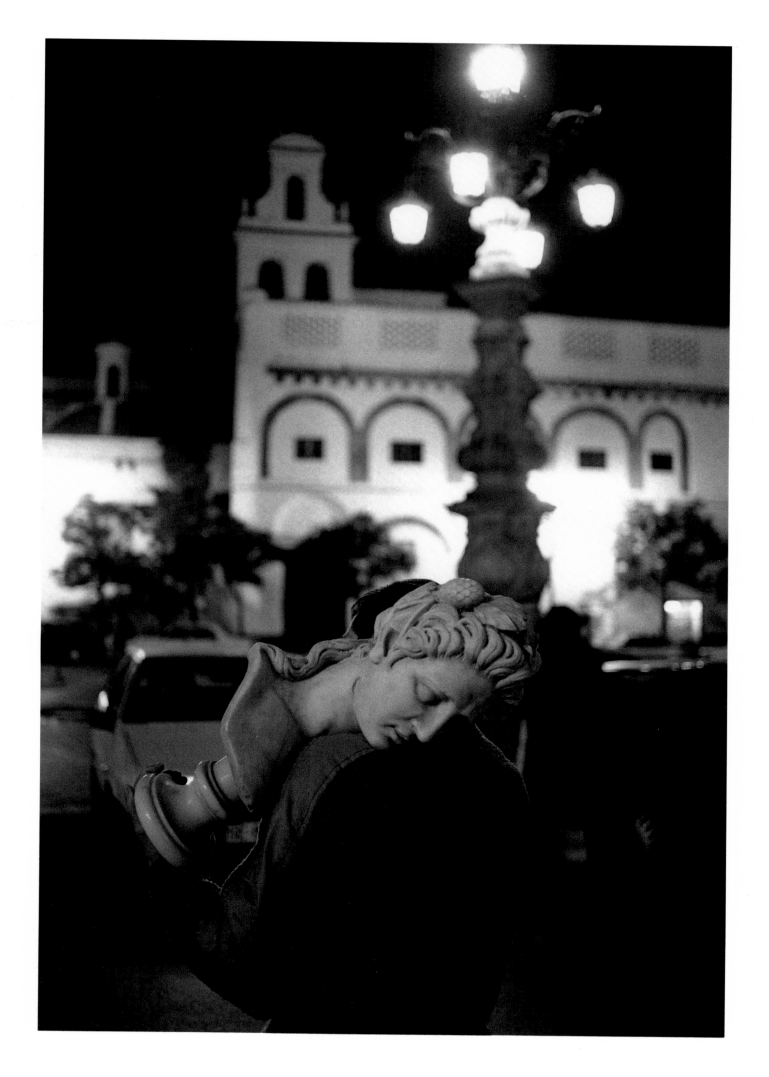

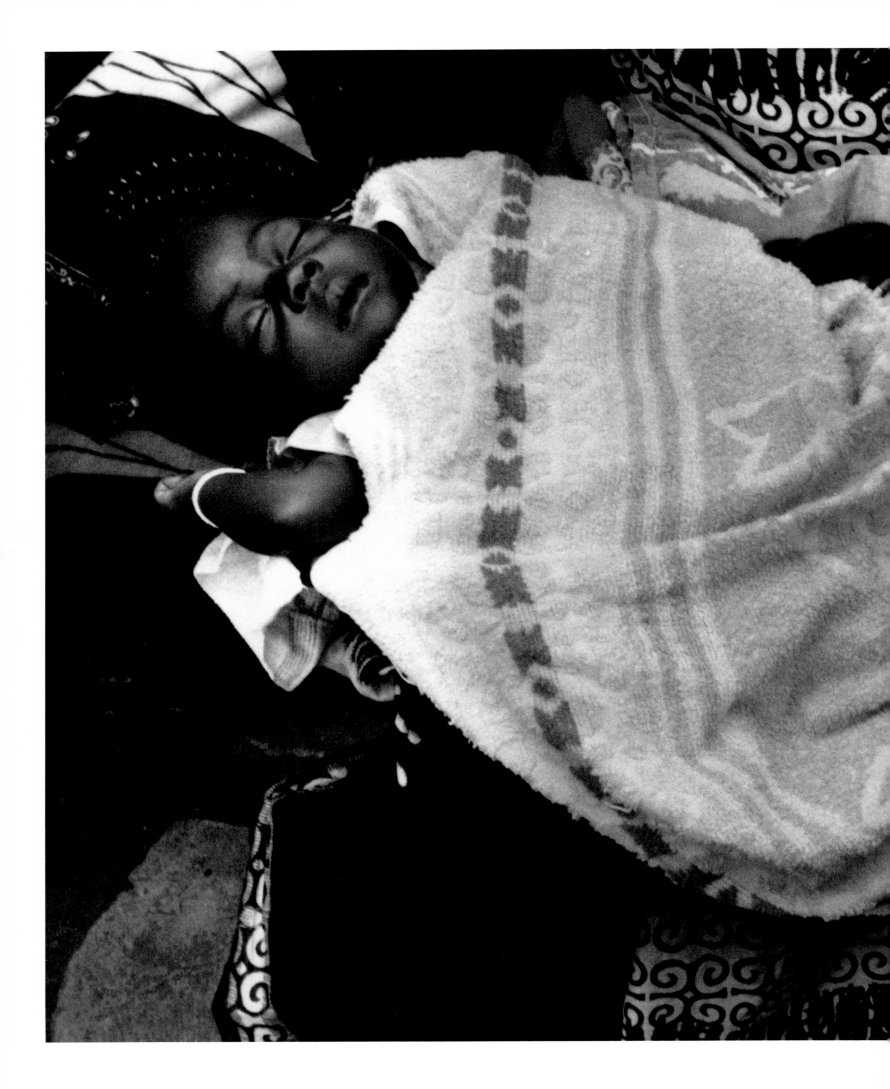

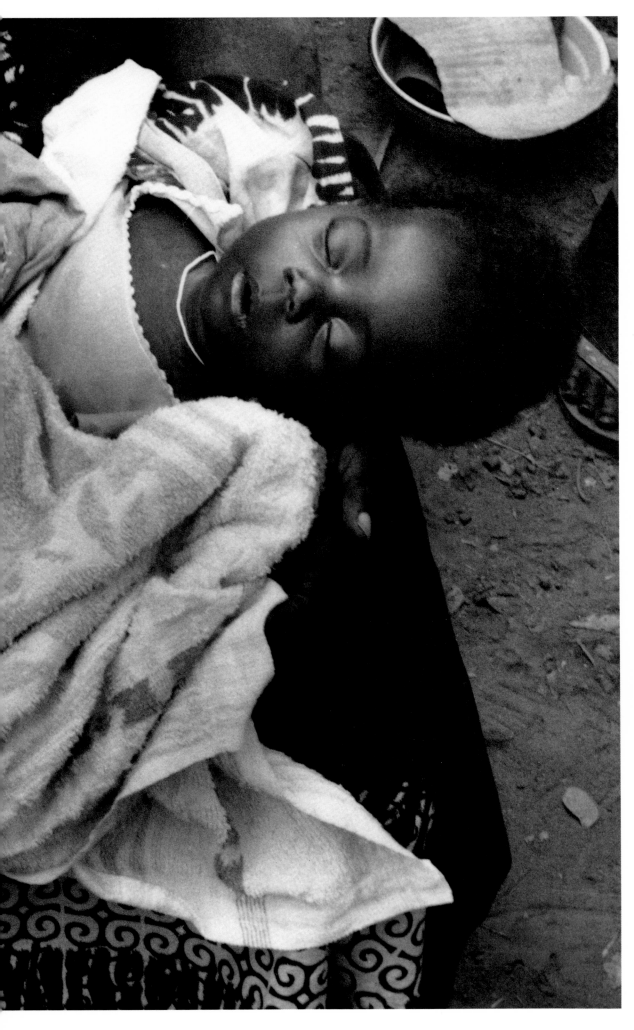

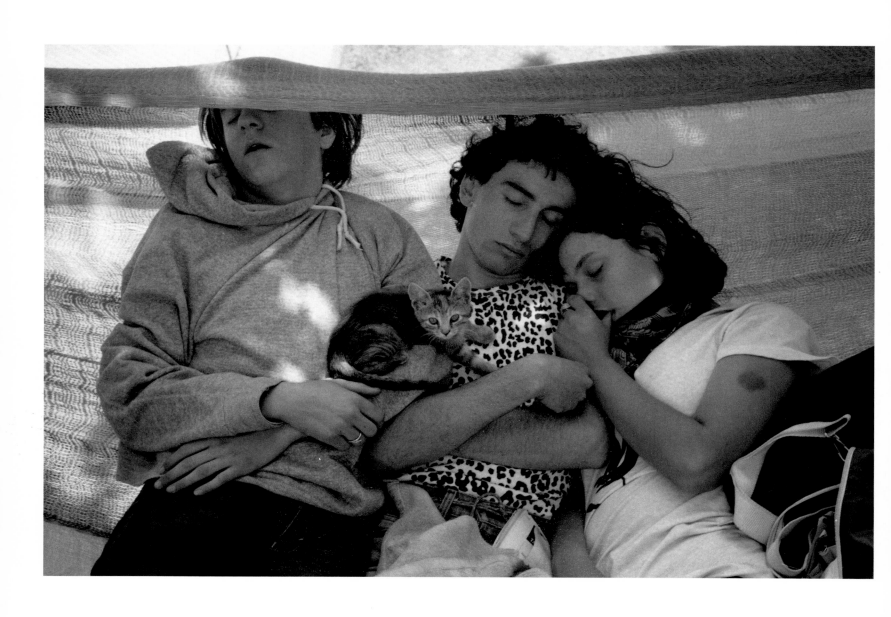

avignon france 1981

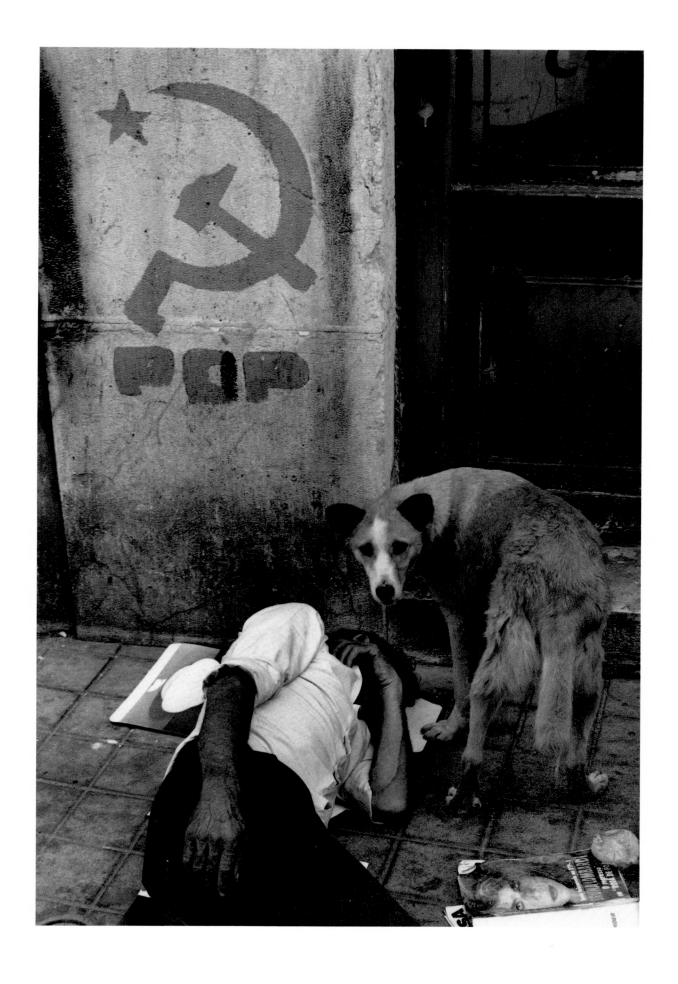

lisbon portugal 1990

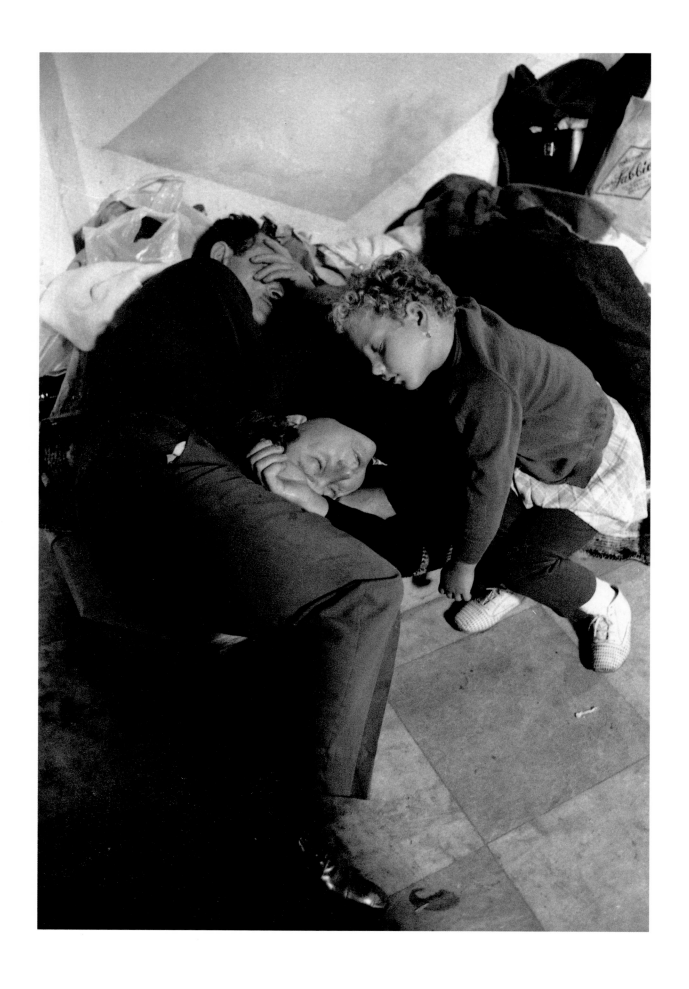

polsi italy 1971

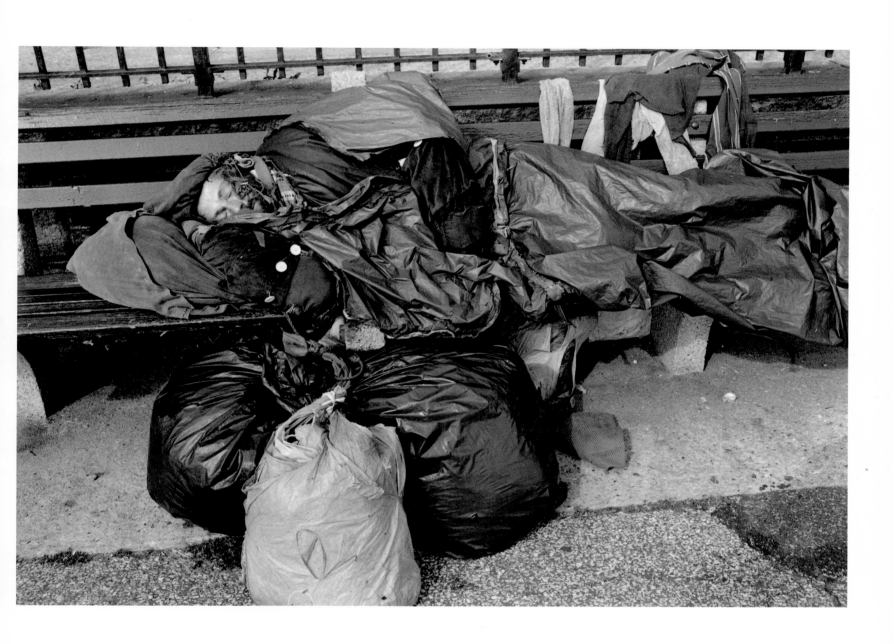

new york united states 1985

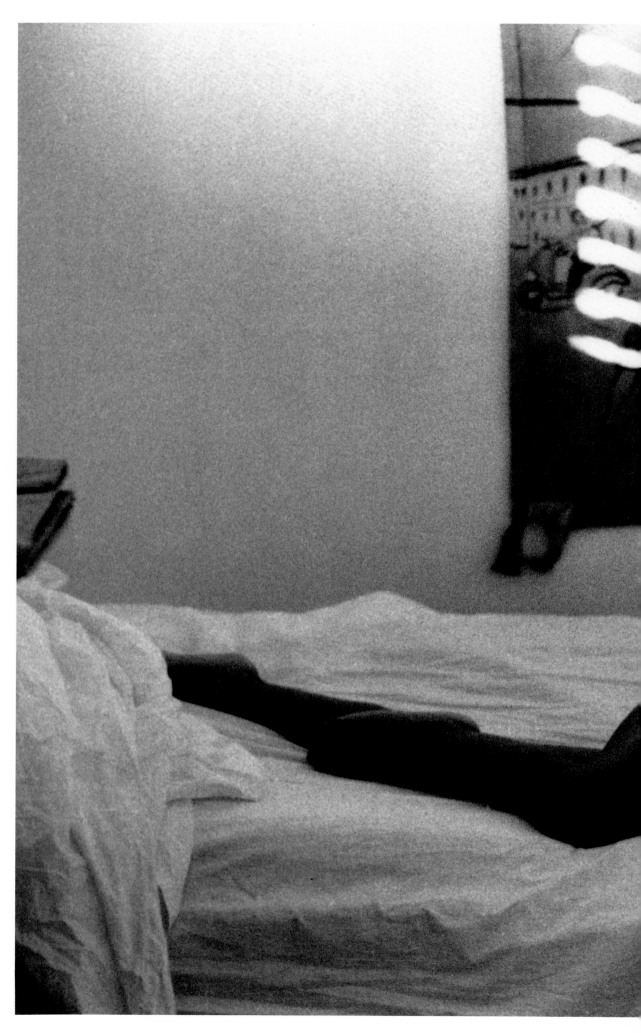

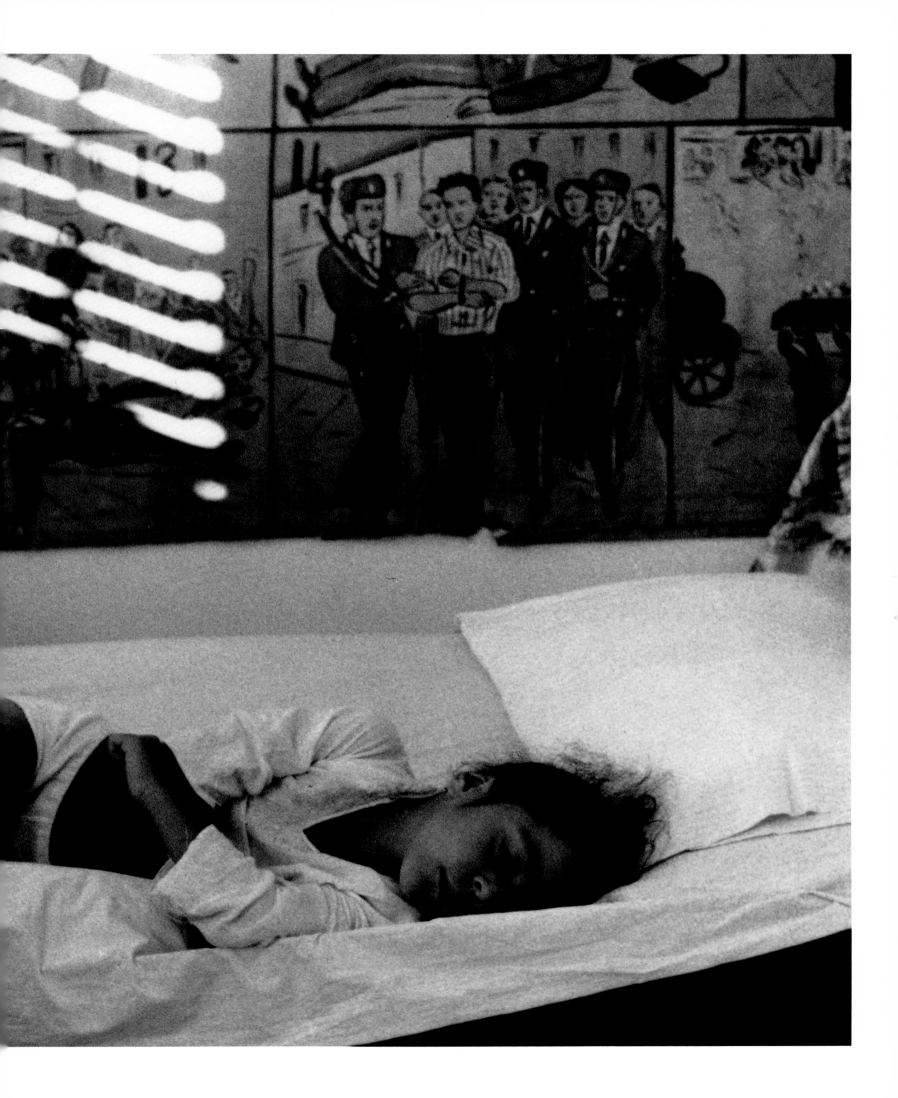

O thou that sleepest, what is sleep? Sleep resembles death. Ah, why then dost thou not work in such wise that after death thou mayst retain a resemblance to perfect life, rather than during life make thyself like the hapless dead by sleeping?
Leonardo da Vinci, Literary and Philosophical Fragments

I grant that perfect repose is, almost of necessity, a complement to love, a mutual harmony whose notes reverberate between two bodies. But what interests me is the specific mystery of sleep entered into for itself alone, the inevitable plunge risked each night by the naked man, solitary and unarmed, into an ocean where everything changes – the colours, the densities and even the rhythm of breathing – and where we meet the dead.
Marguerite Yourcenar, Memoirs of Hadrian

Sleep, angry beauty, sleep, and fear not me.
For who a sleeping lion dares provoke?
It shall suffice me here to sit and see
Those lips shut up, that never kindly spoke.
What sight can more content a lover's mind
Than beauty seeming harmless, if not kind?
 My words have charmed her, for secure she sleeps
Though guilty much of wrong done to my love;
And in her slumber, see! she, close-eyed, weeps!
Dreams often more than waking passions move.
Plead, Sleep, my cause, and make her soft like thee,
That she in peace may wake and pity me.
Thomas Campion, Sleep, Angry Beauty

O Lord, give me my daily dream!
Georges Rodenbach, At the Soul's Edge

In dreaming man reveals himself to himself in all his nakedness and native misery.
L. F. Alfred Maury, Sleep and Dreams

The hills have fallen asleep
O'er cleft and crag;
One quiet spreads
O'er rocks that face the deep
And stony torrent beds.
Alcman, The Hills have Fallen Asleep

Sleep, O Sleep,
With thy rod of incantation
Charm my imagination
…
 What's to sleep?
'Tis a visionary blessing;
A dream that's past expressing;
Our utmost wish possessing
So may I always keep.
John Gay, Polly, II.i

Come worthy Greek, Ulysses come
 Possess these shores with me:
The winds and seas are troublesome,
 And here we may be free.
Here we may sit, and view their toil
 That travail on the deep,
And joy the day in mirth the while,
 And spend the night in sleep.
Samuel Daniel, Ulysses and the Siren

I arise from dreams of thee
In the first sweet sleep of night.
When the winds are breathing low,
And the stars are shining bright:
I arise from dreams of thee.
Percy Bysshe Shelley, Hymn to Intellectual Beauty

If there were dreams to sell,
 What would you buy?
Some cost a passing bell;
 Some a light sigh,
That shakes from Life's fresh crown
Only a roseleaf down.
If there were dreams to sell,
Merry and sad to tell,
And the crier rung the bell,
 What would you buy?
Thomas Lovell Beddoes, Dream-Pedlary

Life, death; and divine
Sleep came of this embrace.
Armand Sully-Prudhomme, Thoughts

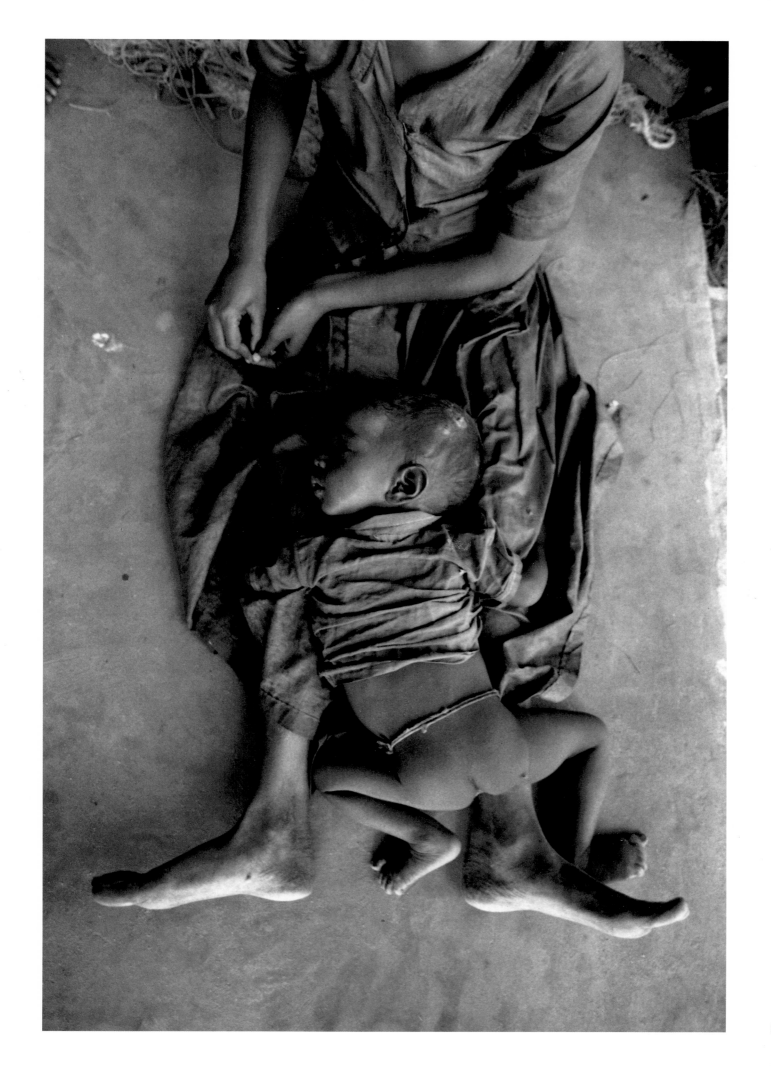

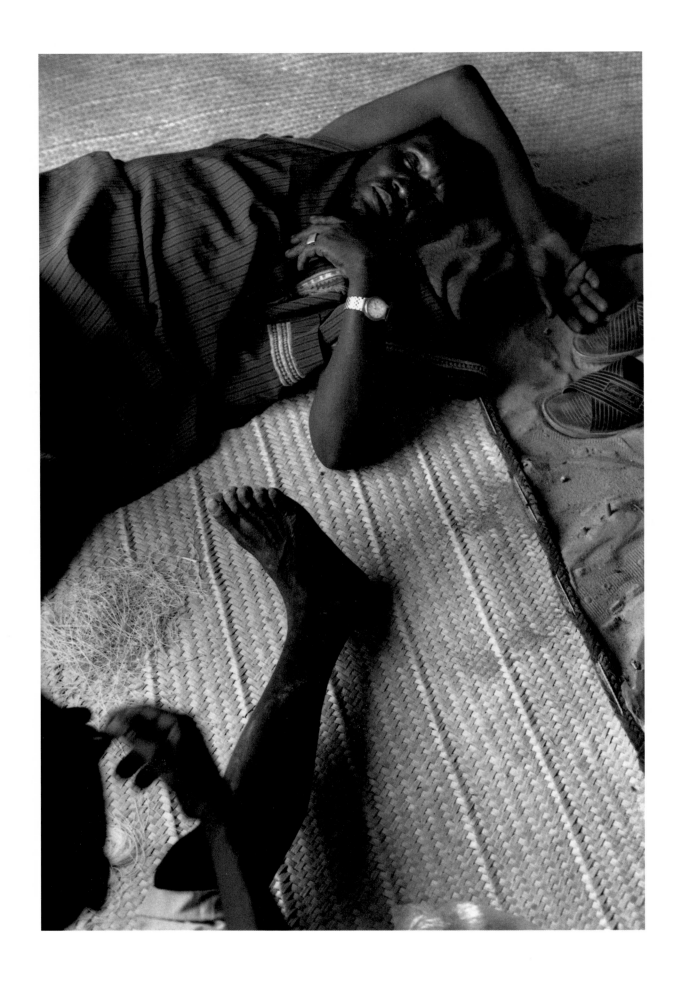

youvarou mali 1993

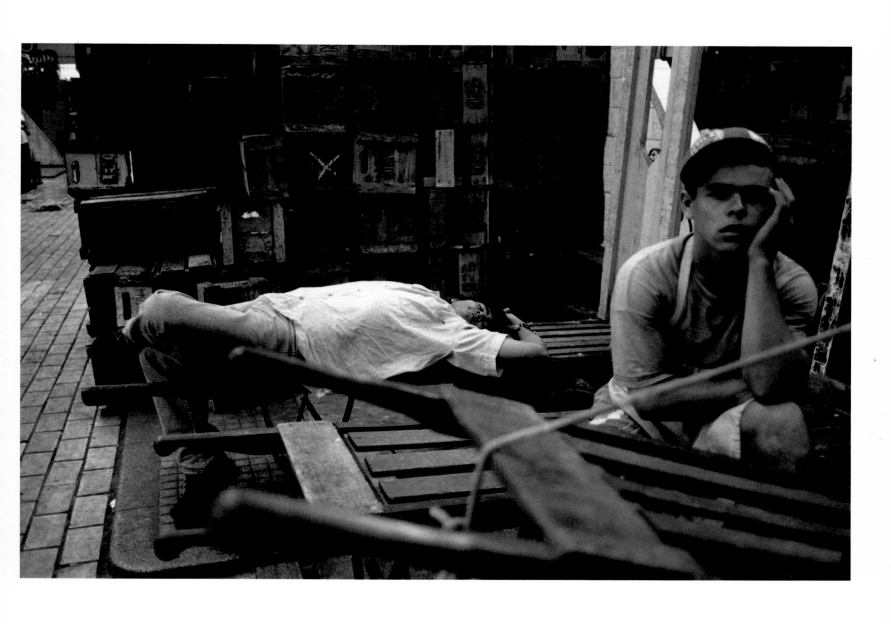

são paulo brazil 1996

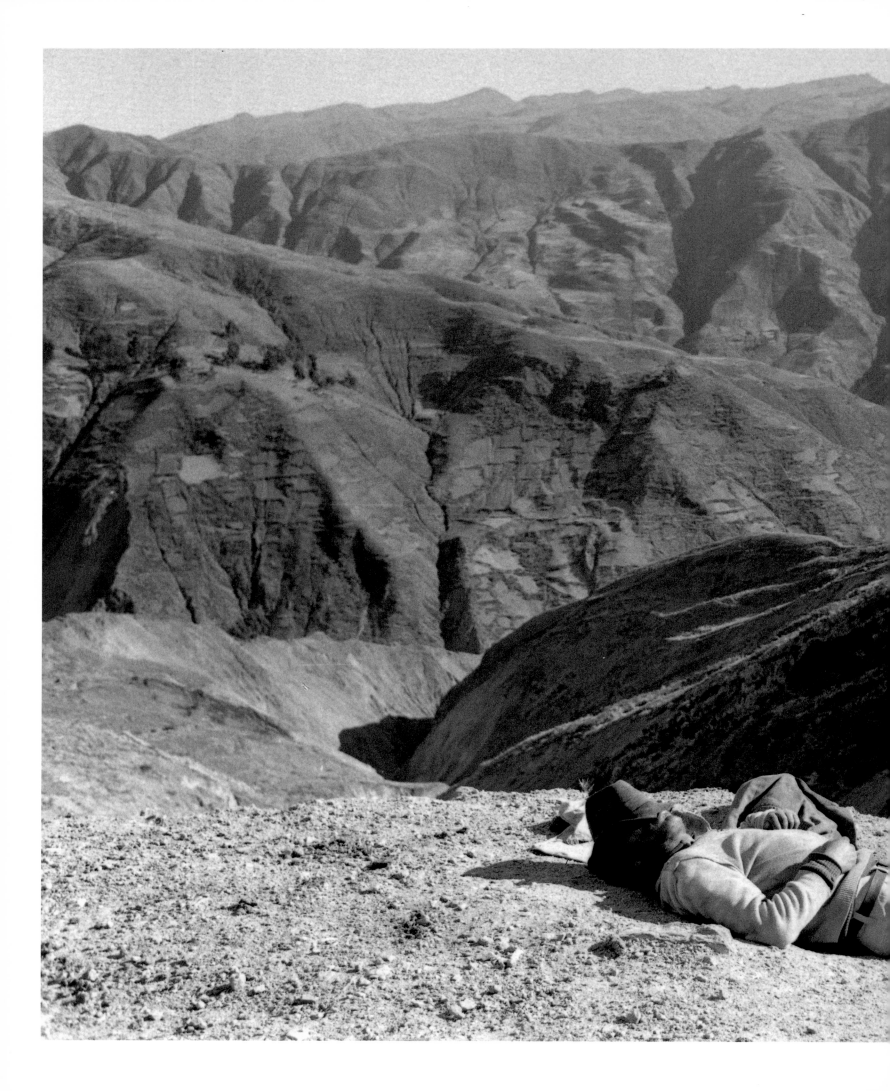

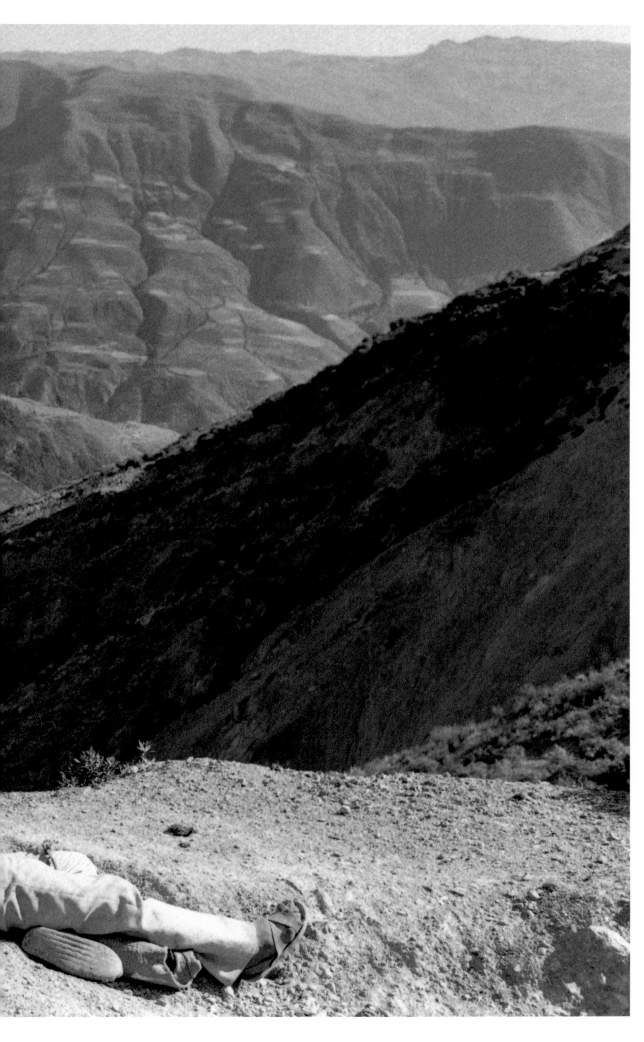

kami bolivia 1986 93

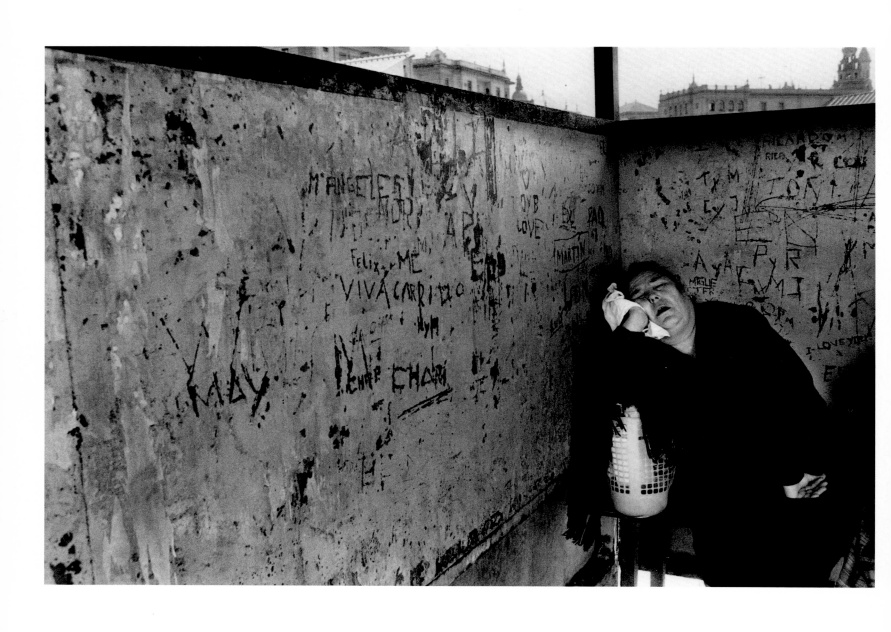

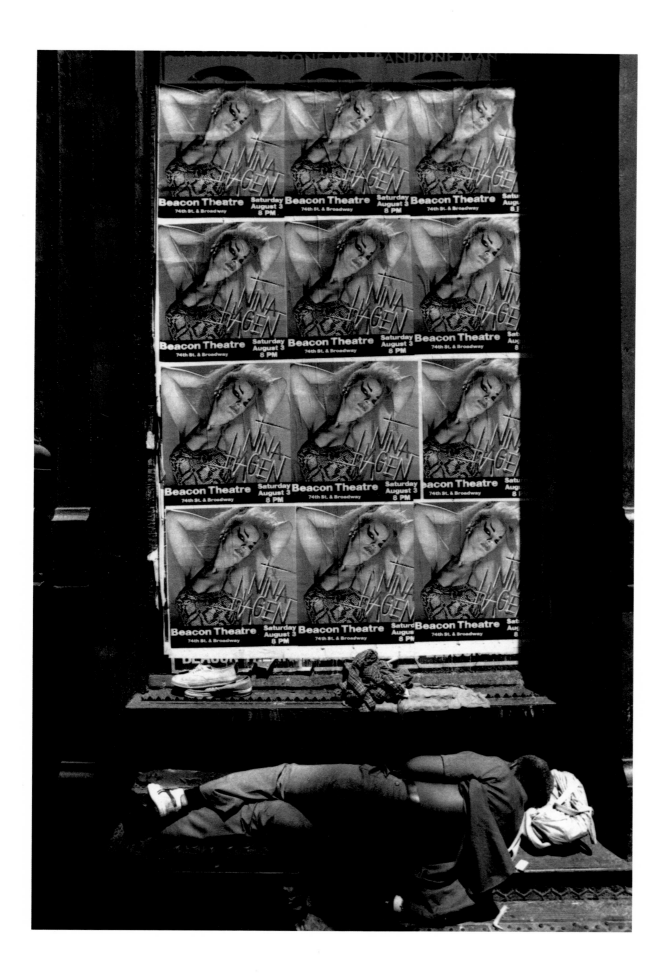

new york united states 1985

Sleep is a death, O make me try,
By sleeping what it is to die.
And as gently lay my head
On my grave, as now my bed.

Sir Thomas Browne, Religio Medici, part ii, section 31

Welcome is sleep, and more welcome to be of stone,
while the injury and shame last.

Michelangelo, reply to Giovanni Strozzi's quatrain
on Michelangelo's 'Night'

Dream is the never-ending shadow of Truth.

Giovanni Pascoli, Alexandros

Then star nor sun shall waken,
 Nor any change of light:
Nor sound of waters shaken,
 Nor any sound or sight:
Nor wintry leaves nor vernal,
Nor days nor things diurnal;
Only the sleep eternal
 In an eternal night.

Algernon Charles Swinburne,
The Garden of Proserpine

Care-charmer Sleep, son of the sable night,
Brother to Death, in silent darkness born:
Relieve my languish, and restore the light,
With dark forgetting of my care return,
And let the day be time enough to mourn
The shipwreck of my ill adventured youth.

Samuel Daniel, Sonnets to Delia, liv

 … a sleep
Full of sweet dreams, and health, and quiet breathing.

John Keats, Endymion, i.4–5

Some say that gleams of a remoter world
Visit the soul in sleep, – that death is slumber,
And that its shapes the busy thoughts outnumber
Of those who live and wake.

Percy Bysshe Shelley, Mont Blanc, 49–52

Unarm, Eros; the long day's task is done,
And we must sleep.

William Shakespeare, Antony and Cleopatra, III.xii.35–6

But I, being poor, have only my dreams;
I have spread my dreams under your feet;
Tread softly, because you tread on my dreams.

William Butler Yeats,
He Wishes for the Cloths of Heaven

Father, O father! what do we here
In this land of unbelief and fear?
The land of dreams is better far,
Above the light of the morning star.

William Blake, The Land of Dreams

… the unconscious sleep is the relatively happiest
condition, because it is the only painless one known
to us in normal life … As for dreams, all the troubles
of the waking state are prolonged into the dormant
condition.

Eduard von Hartmann,
The Philosophy of the Unconscious

In a word, as we often dream that we dream, and
heap vision upon vision, it may well be that this life
itself is but a dream … from which we wake at death.

Blaise Pascal, Pensées

Sleep devours existence, this is its good side: 'The
hours are long, and life is short,' says Fénelon.

François de Chateaubriand,
Memoirs from beyond the Grave

'God's blessing', said Sancho Panza, 'be upon the
man who first invented this self-same thing called
sleep – it covers a man all over like a cloak.'

Laurence Sterne, Tristram Shandy

This is the dream of my ultimate wisdom.
And like all dreams, useless.

Umberto Saba, Dream

O sleep, most pleasant stillness of all things, and true
peace of mind, you who flee all cares like enemies …
Tamer of ills and best part of human life … Languid
brother of harsh death, you who mingle the true
with the false … Haven of life, rest of light and com-
panion of the night …

Giovanni Boccaccio, The Elegy of Madonna Fiammetta

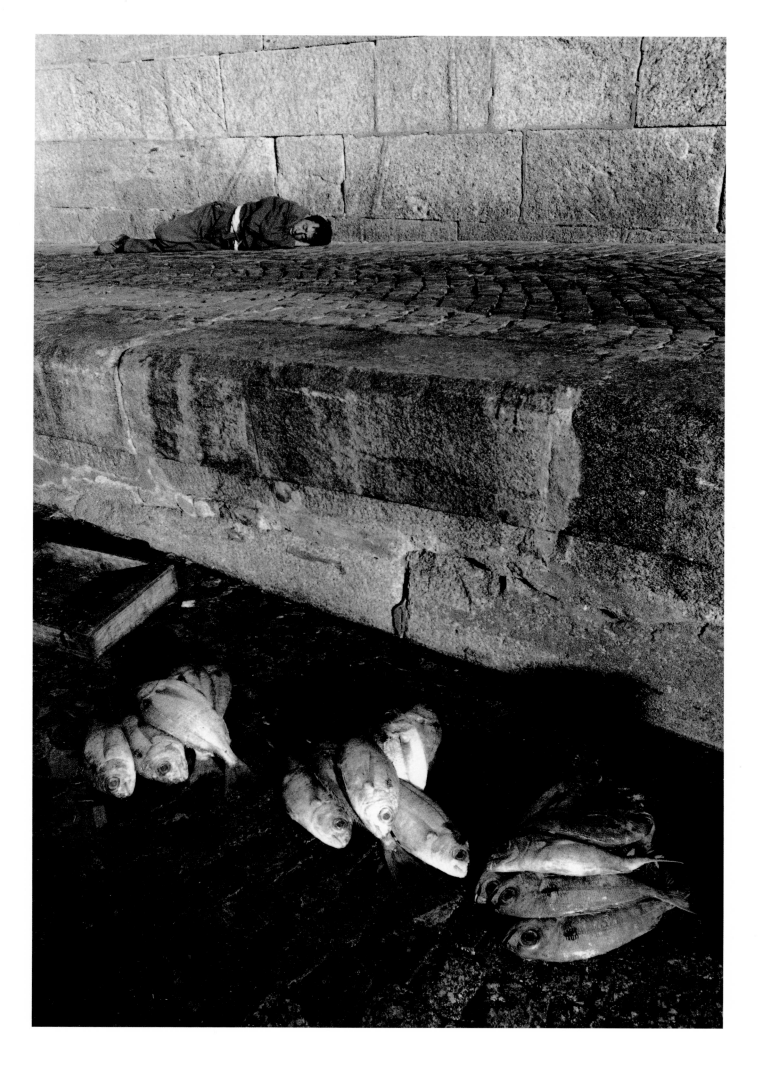

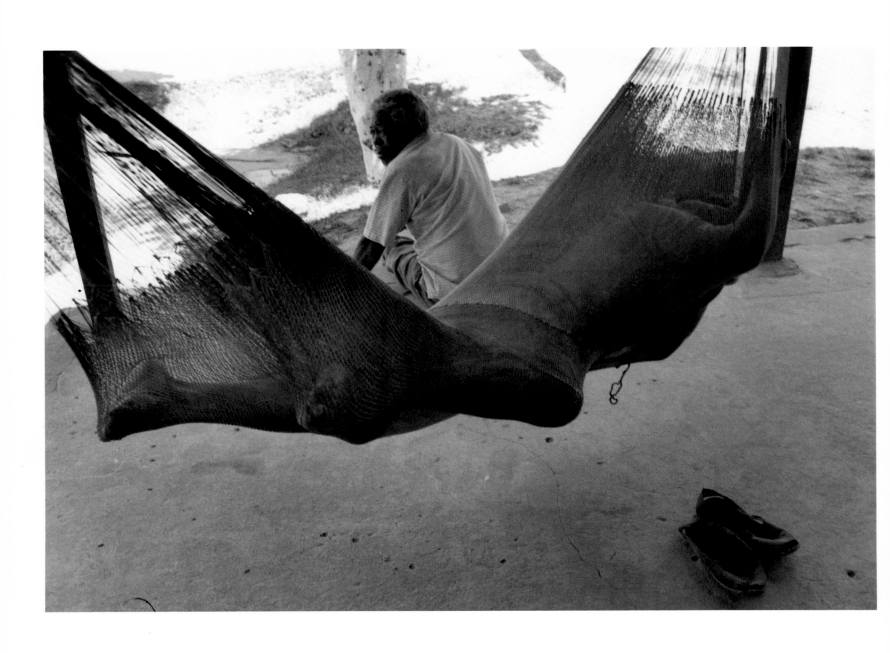

villavicencio colombia 1988

rome italy 1964

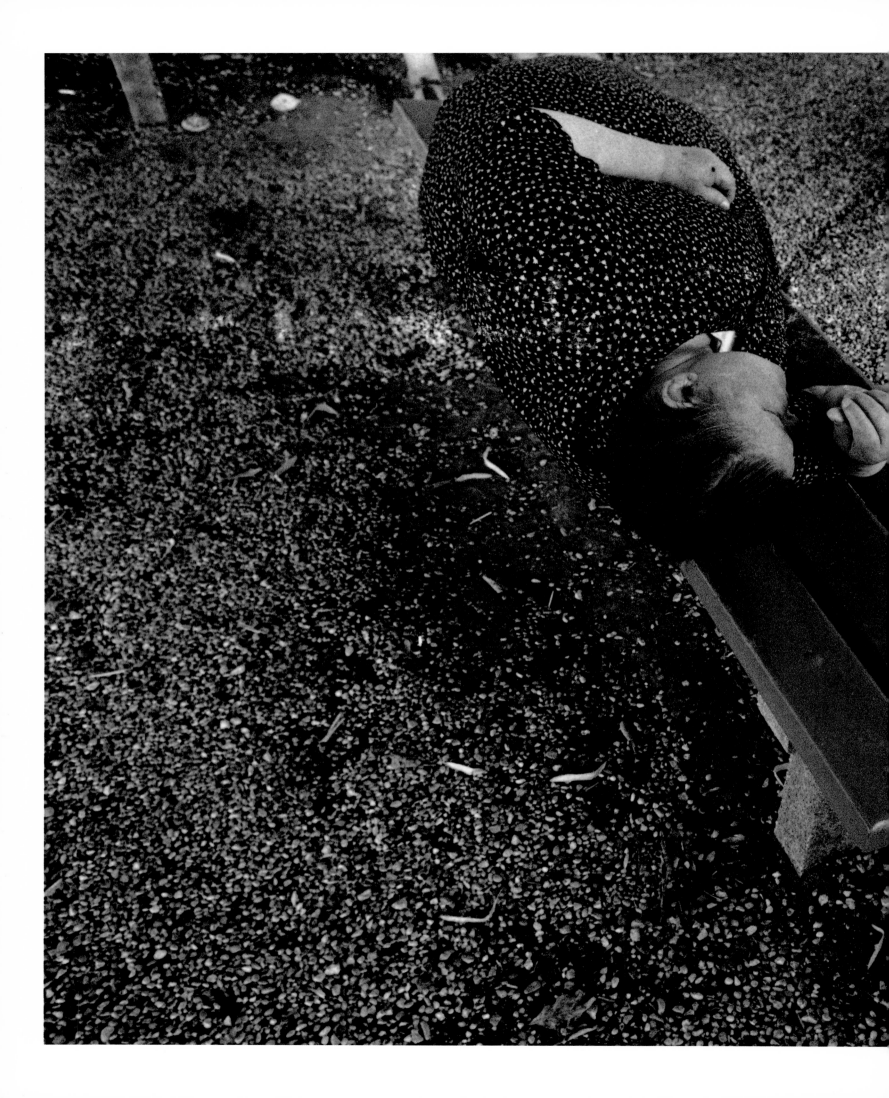

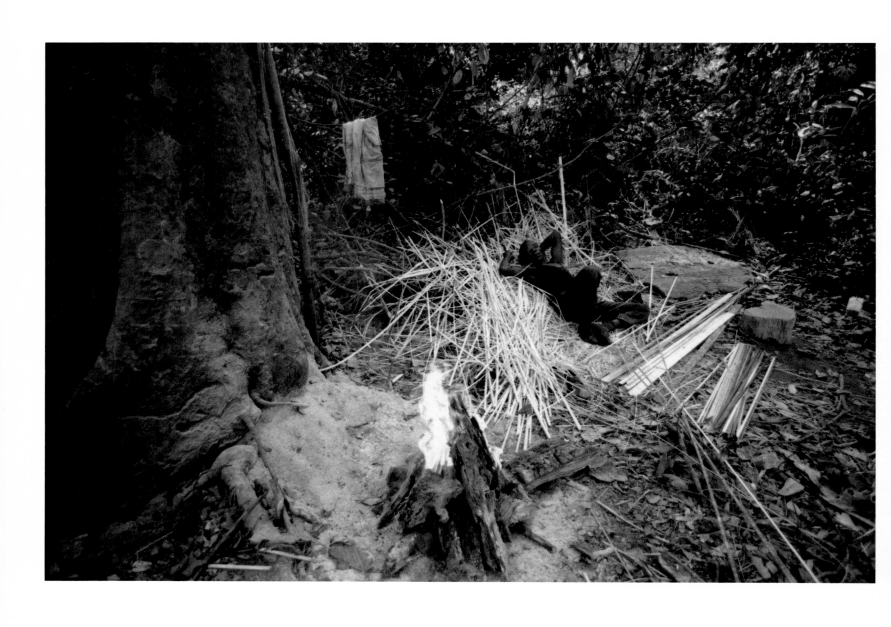

ivory coast 1972

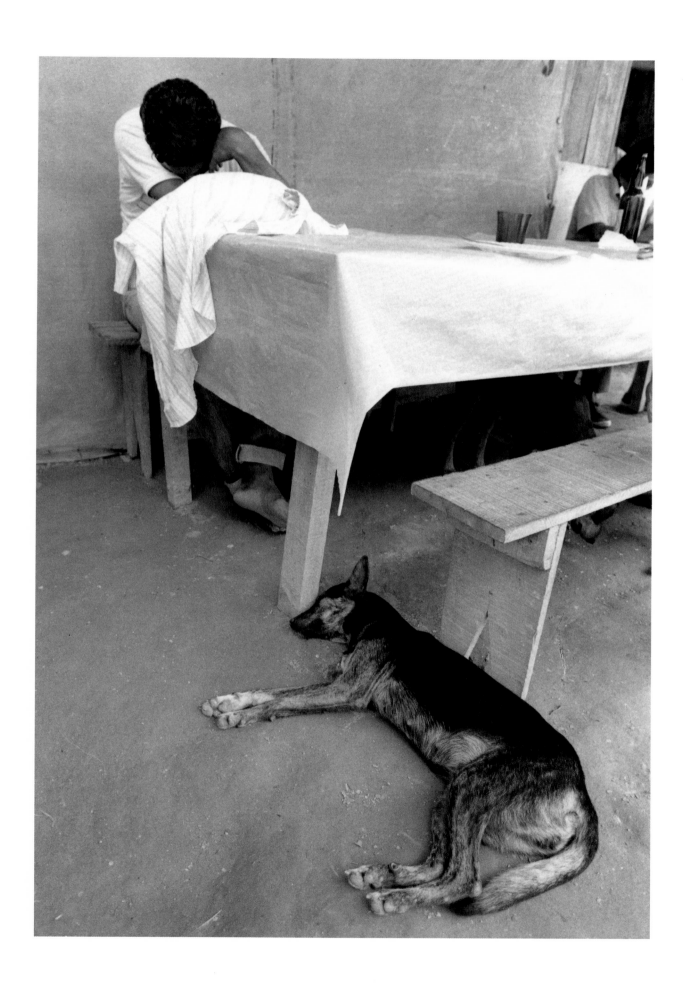

san augustin colombia 1987

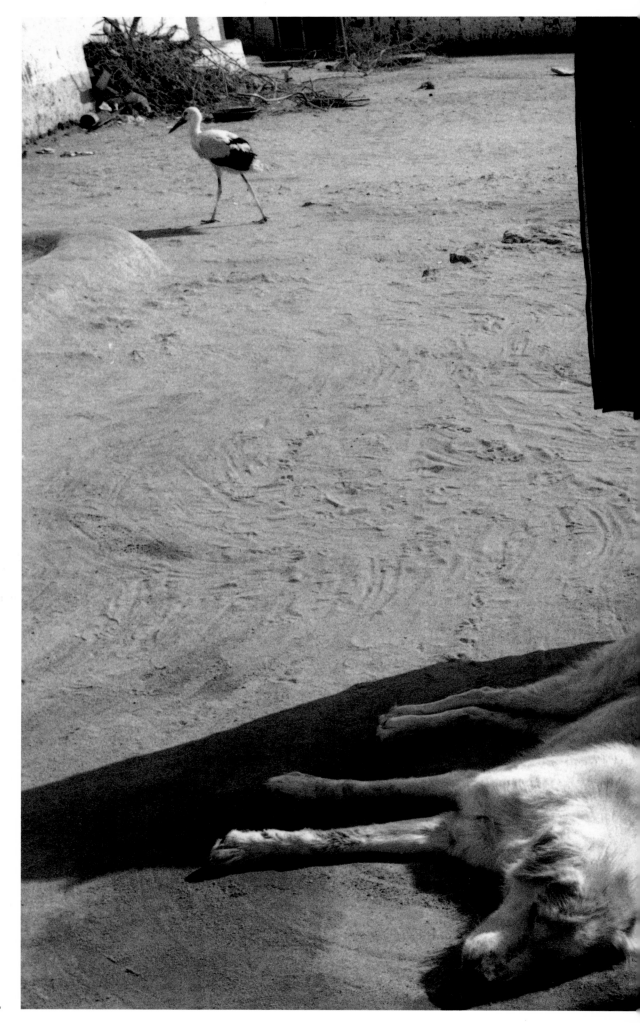

aswan egypt 1992

All that we see or seem
Is but a dream within a dream.

> *Edgar Allan Poe,* A Dream within a Dream

To kill the baby and then sleep, sleep, sleep … Va'rka creeps up to the cradle and bends over the child. She suffocates him, and immediately lies down on the floor, laughs for joy at the thought of sleep, and a minute later is already asleep, sleeping deeply, like a dead body.

> *Anton Chekhov,* The Desire to Sleep

To all, to each, a fair good-night,
And pleasing dreams, and slumbers light!

> *Sir Walter Scott,* L'Envoy

Sleep, now come quietly,
Like a mother to her child;
Around the feeble flame
You draw a protecting circle.

> *Friedrich Hebbel,* Nocturne

I have put my days and dreams out of mind,
Days that are over, dreams that are done.

> *Algernon Charles Swinburne,* The Triumph of Time

I could lie down like a tired child,
And weep away the life of care
Which I have borne and yet must bear,
Till death like sleep might steal on me.

> *Percy Bysshe Shelley,*
> Stanzas Written in Dejection near Naples

Care-charming Sleep, thou easer of all woes,
Brother to Death.

> *Francis Beaumont and John Fletcher,*
> Valentinian, V.ii

With thousand such enchanting dreams, that meet
To make sleep not so sound, as sweet.

> *Robert Herrick,* Hesperides. A County Life:
> to his Brother, M. Tho. Herrick

Flow gently, sweet Afton, among thy green braes,
Flow gently, I'll sing thee a song in thy praise.
My Mary's asleep by thy murmering stream,
Flow gently, sweet Afton, disturb not her dream.

> *Robert Burns,* Flow Gently, Sweet Afton

Between sleep and dream,
Between me and my imagined self,
An endless river flows.

> *Ferdinando Pessoa,* The Reaper

Half our days we pass in the shadow of the earth, and the brother of death exacteth a third part of our lives. A good part of our sleep is pieced out with visions, and phantastical objects wherein we are confessedly deceaved. The day supplyeth us with truths, the night with fictions and falsehoods.

> *Sir Thomas Browne,* On Dreams

Life and dreams are leaves from the same book … we are forced to concede to the poets that life is one long dream.

> *Arthur Schopenhauer*

If only life could be more than a disappointed dream.

> *René Char,* Leaves of Hypnos

I fear sleep like one fears a large hole
Full of vague horrors, leading no one knows where.

> *Charles Baudelaire,* The Abyss

A few more years shall roll,
 A few more seasons come,
And we shall be with those that rest,
 Asleep within the tomb.

> *Horatius Bonar,* Songs for the Wilderness.
> A Few More Years

Was it a vision, or a waking dream?
Fled is that music: – Do I wake or sleep?

> *John Keats,* Ode to a Nightingale

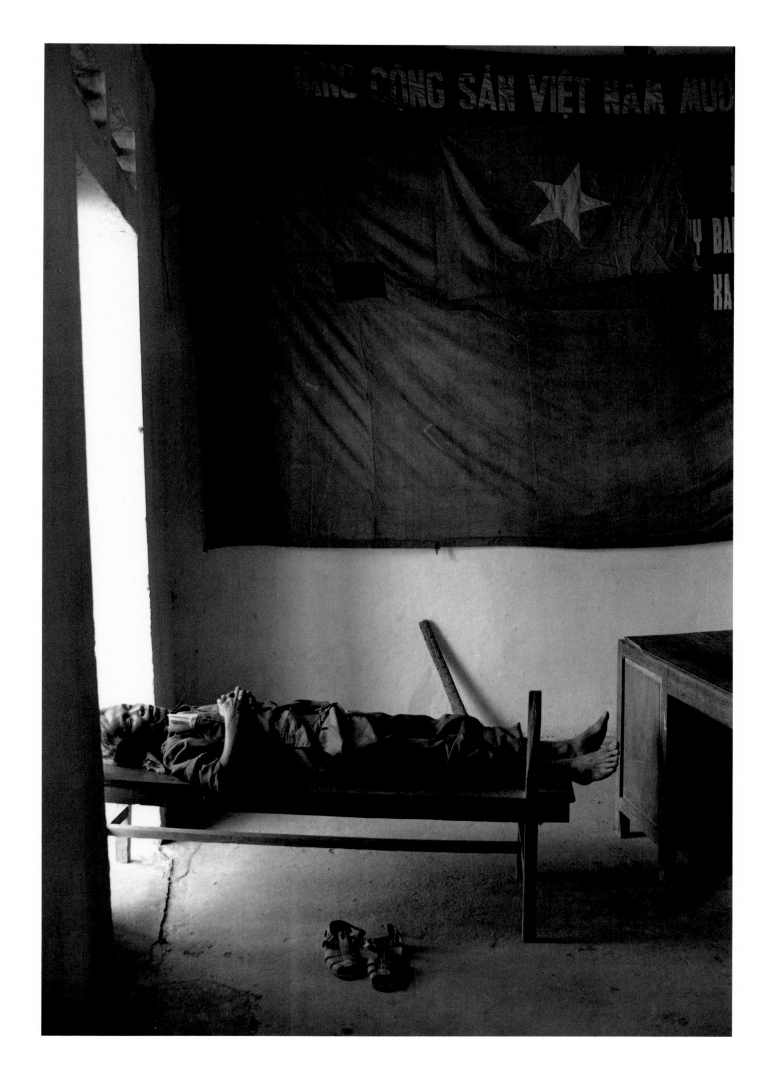

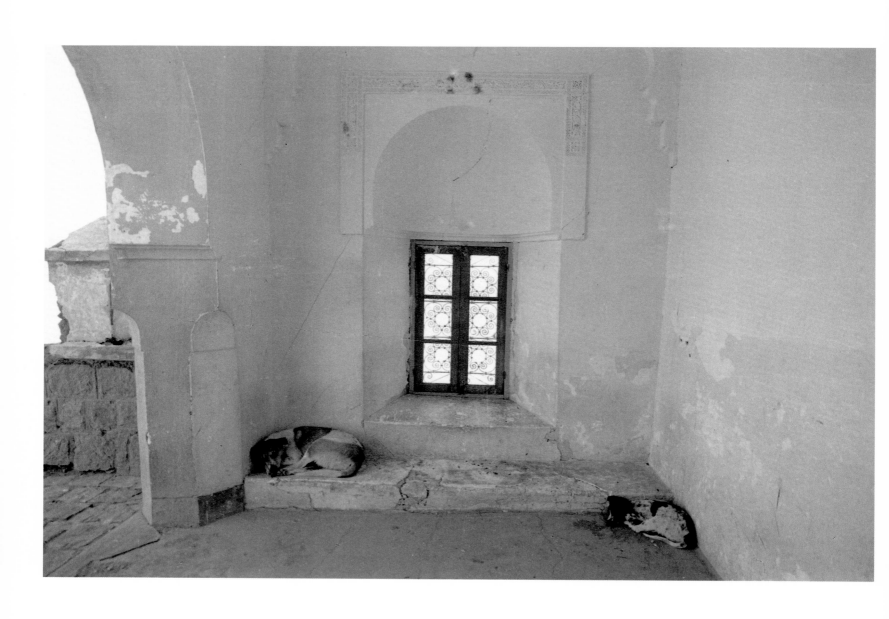

bouma lué morocco 1972

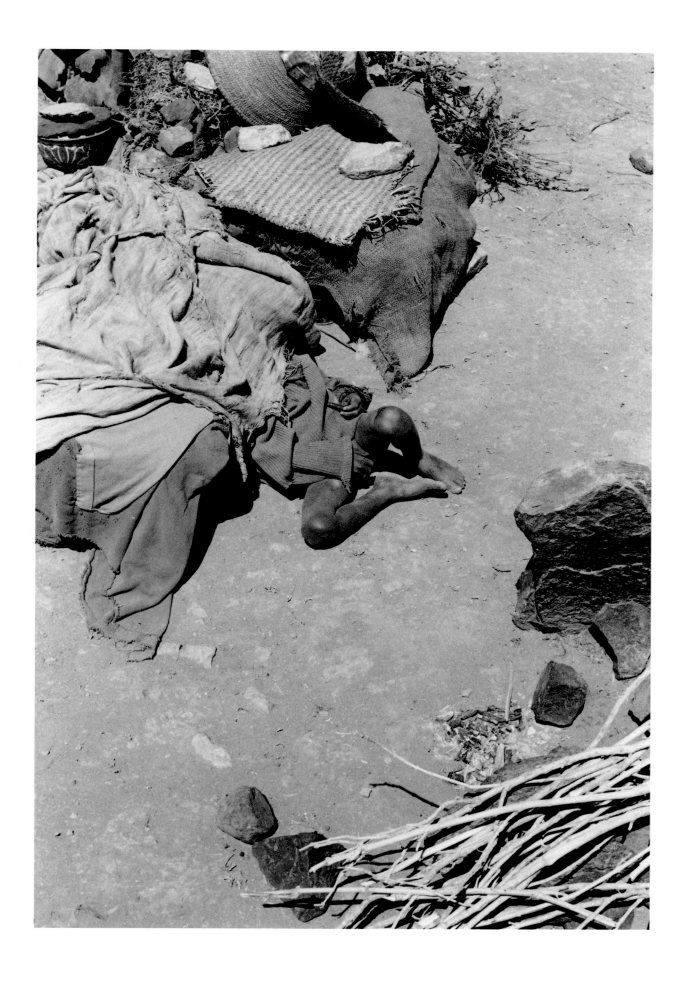

macallé ethiopia 1984

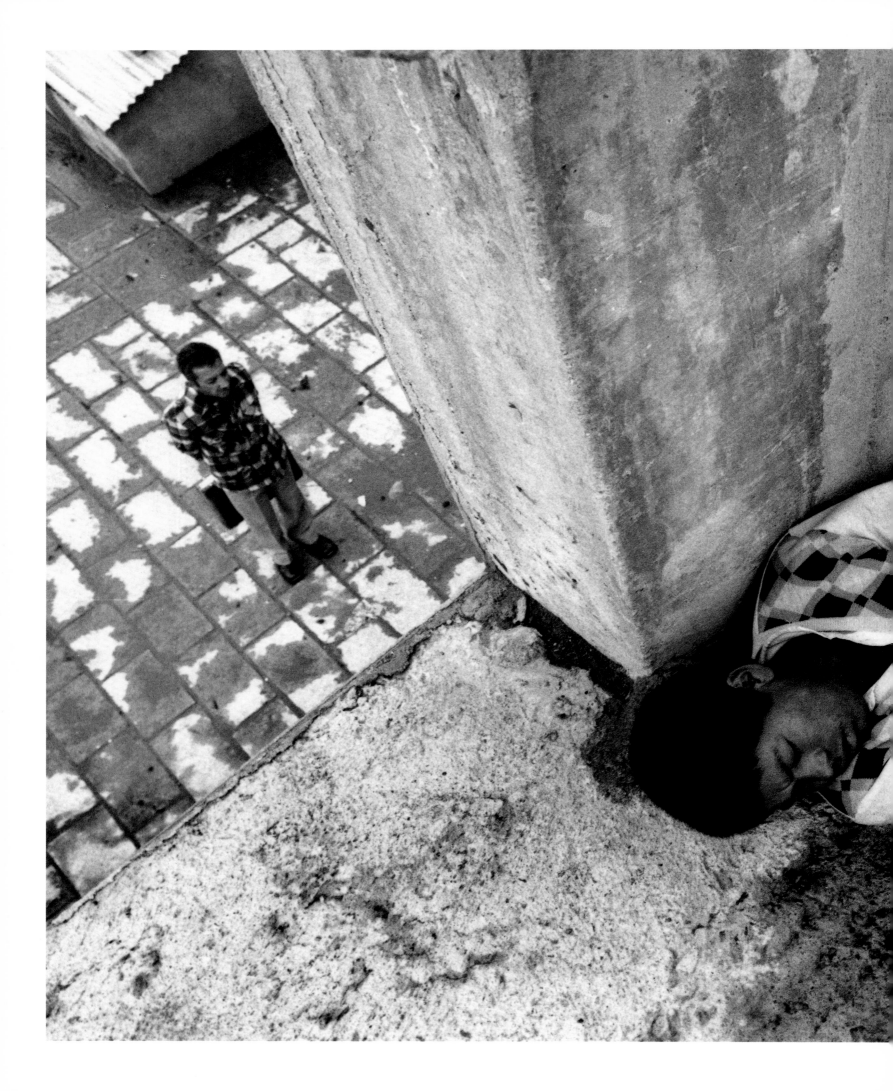

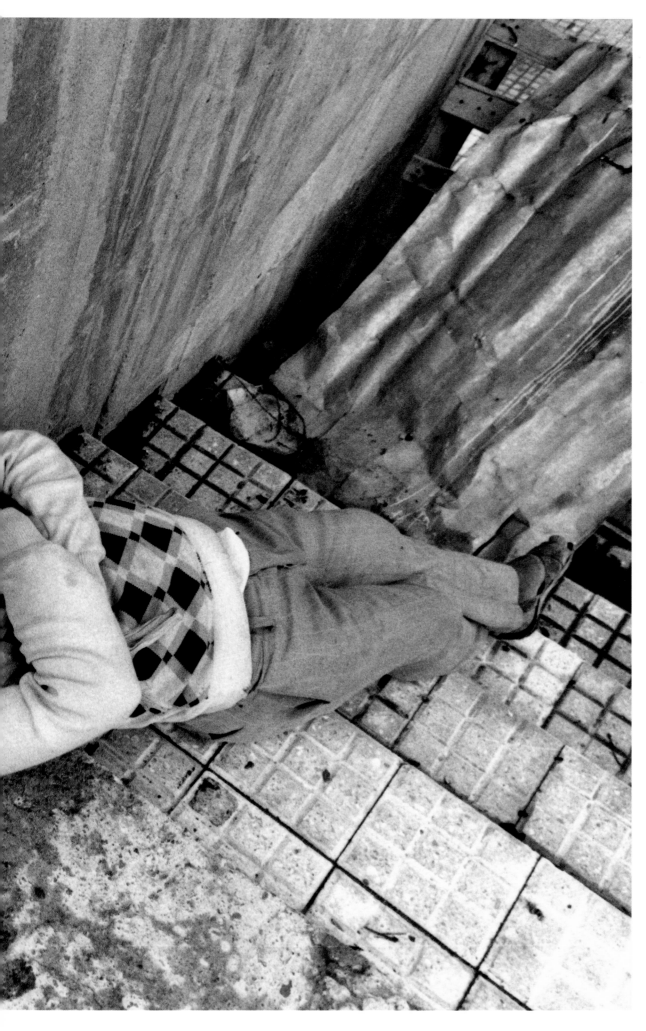

I went to sleep after midnight, woke up at five, a splendid achievement, extraordinary luck, and what's more I was still sleepy. But this luck became my misfortune because the inevitable thought came: you do not deserve such luck. All the gods of vengeance descended on me, I could see their leader part his fingers and threaten me, beating menacingly on his drum. My agitation in the two hours up to seven o'clock not only destroyed the benefit of my previous sleep, but left me trembling and restless the whole day.

Franz Kafka, Confessions and Diaries

Six hours of sleep are sufficient for youth and old age; reluctantly we would allow seven to the lazy, but no one can have eight.

Health directive of the city of Salerno

It is not to be wondered at if, weak as I am, I dream of being awake, since awake I see myself asleep.

Pedro Calderón de la Barca, Life is a Dream

I met at eve the Prince of Sleep,
His was a still and lovely face,
He wandered through a valley steep,
Lovely in a lonely place.

Walter de la Mare, I Met at Eve

Golden slumbers kiss your eyes,
Smiles awake you when you rise:
Sleep, pretty wantons, do not cry,
And I will sing a lullaby:
Rock them, rock them, lullaby.

Care is heavy, therefore sleep you;
You are care, and care must keep you.

Thomas Dekker, Patient Grissil, IV.ii

Sleep is, in fine, so like death, I dare not trust it without my prayers.

Sir Thomas Browne, Religio Medici, part ii, section 13

Flocks of the memories of the day draw near
The dovecote doors of sleep.

Alice Meynell, At Night

When all is done, human life is, at the greatest and the best, but like a froward child, that must be play'd with and humoured a little to keep it quiet till it falls asleep, and then the care is over.

Sir William Temple, Essay on Poetry

Enjoy the honey-heavy dew of slumber.

William Shakespeare, Julius Caesar, II.i.230

There have been times when I have fallen asleep in tears; but in my dreams the most charming forms have come to cheer me, and I have risen fresh and joyful.

Johann Wolfgang von Goethe

Rest, rest; the troubled breast
panteth evermore for rest:—
Be it sleep, or be it death
Rest is all it coveteth.

Christina Rossetti, The Dream

The glory and the freshness of a dream.

William Wordsworth, Ode.
Intimations of Immortality, i

Real are the dreams of Gods, and smoothly pass
Their pleasures in a long immortal dream.

John Keats, Lamia, i.127–8

To be, or not to be: that is the question:
Whether 'tis nobler in the mind to suffer
The slings and arrows of outrageous fortune,
Or to take arms against a sea of troubles,
And by opposing end them? To die: to sleep;
No more; and, by a sleep to say we end
The heart-ache and the thousand natural shocks
That flesh is heir to, 'tis a consummation
Devoutly to be wish'd. To die, to sleep;
To sleep: perchance to dream: ay, there's the rub;
For in that sleep of death what dreams may come
When we have shuffled off this mortal coil,
Must give us pause.

William Shakespeare, Hamlet, III.i.56–68

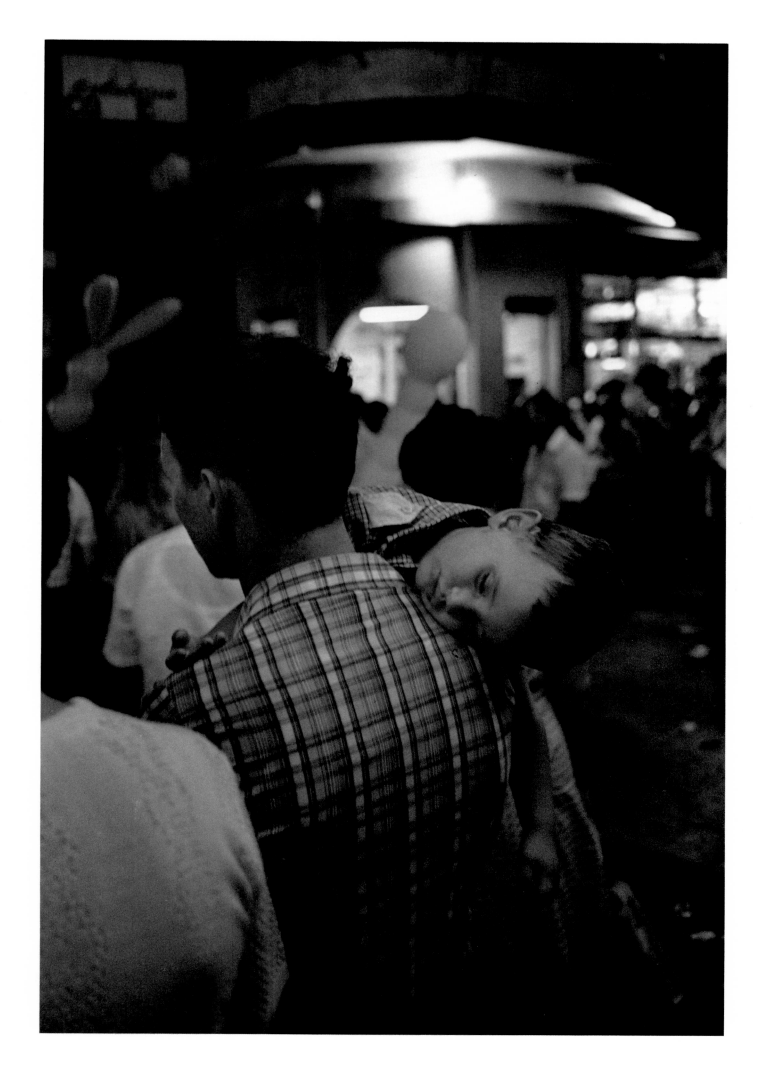

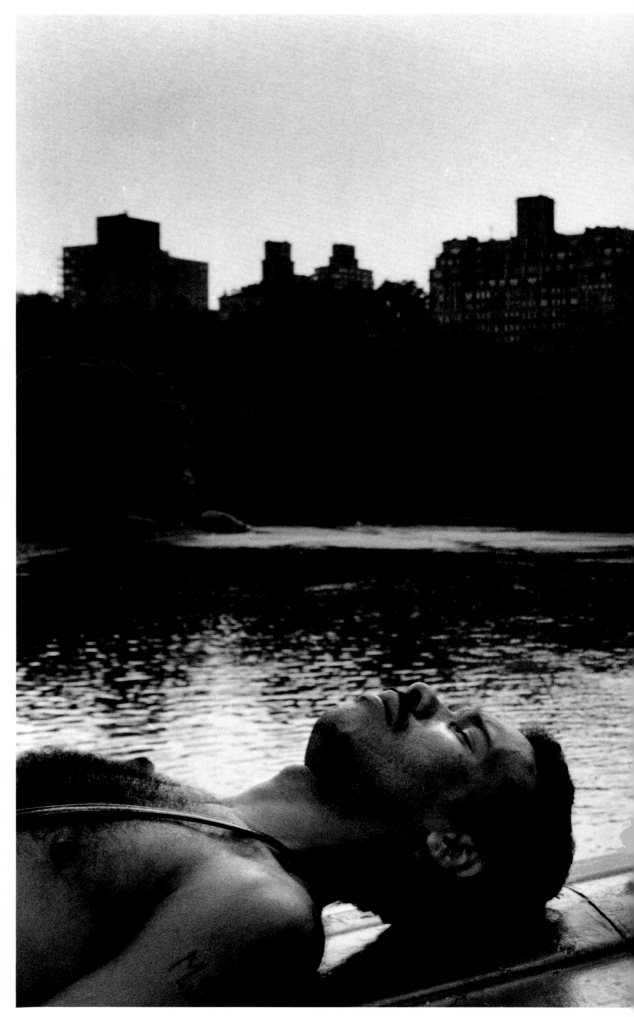

new york united states 1985

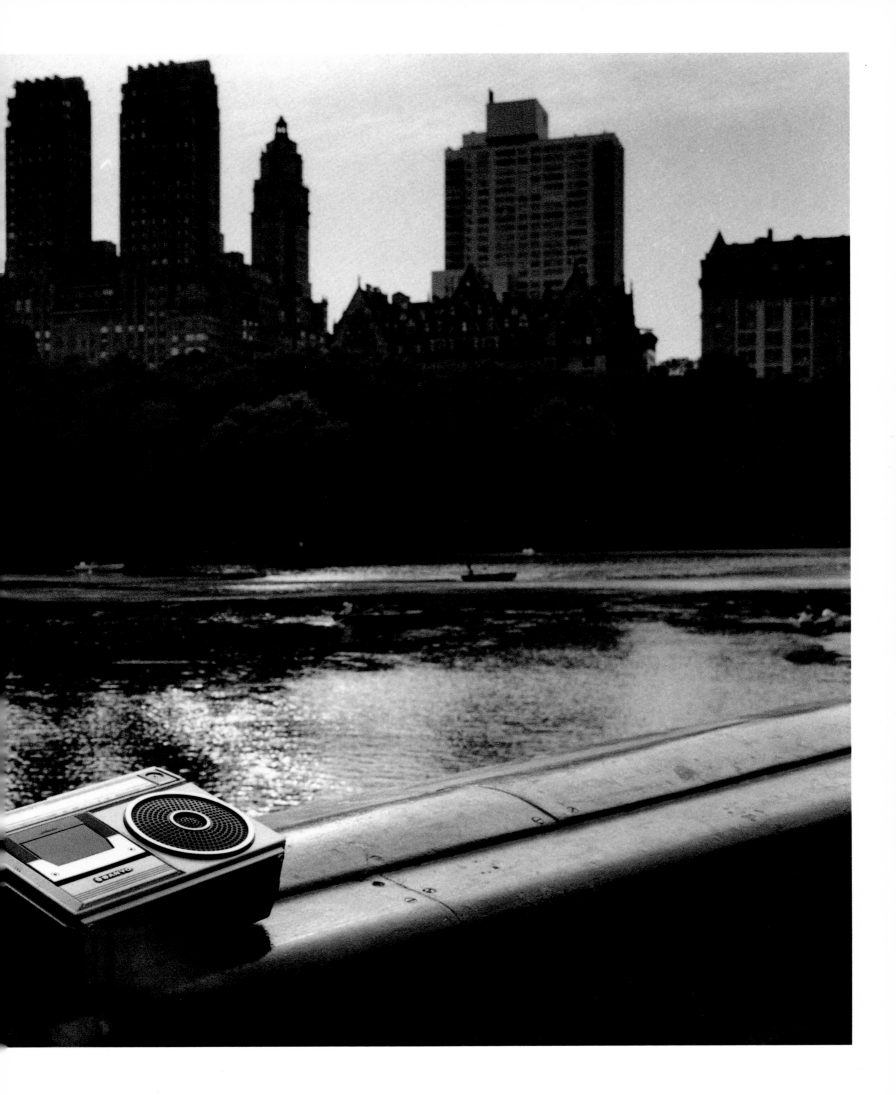

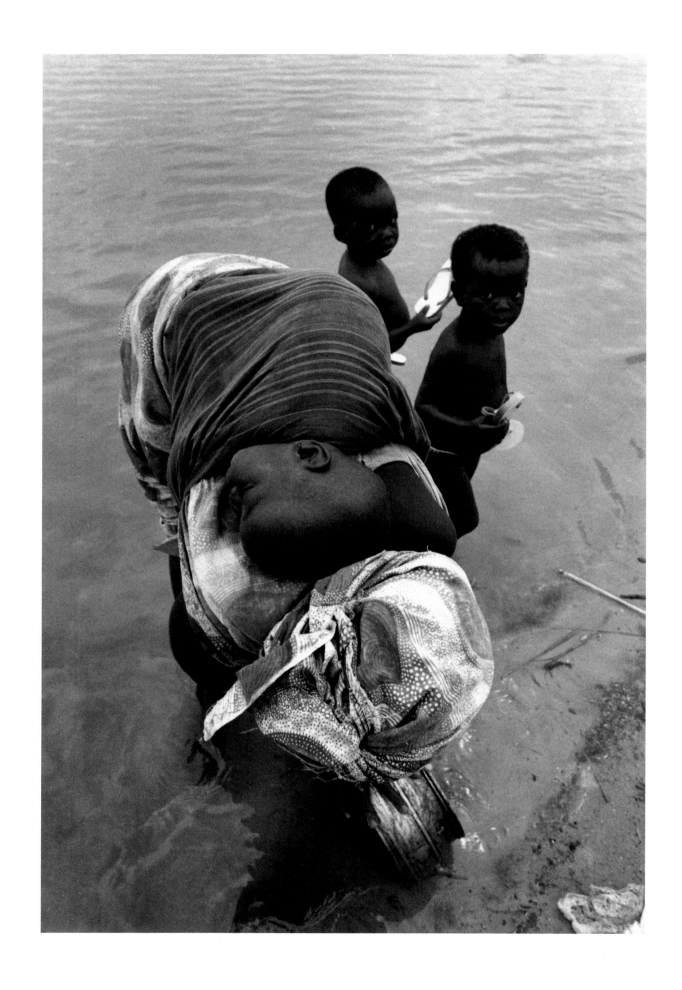

youvarou mali 1993

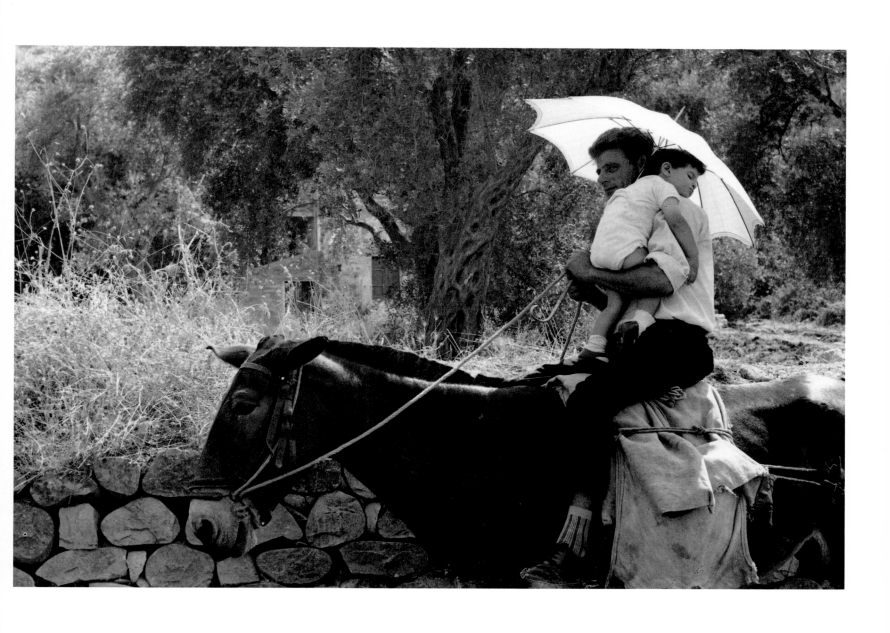

vallelunga sicily 1964

paris france 1989

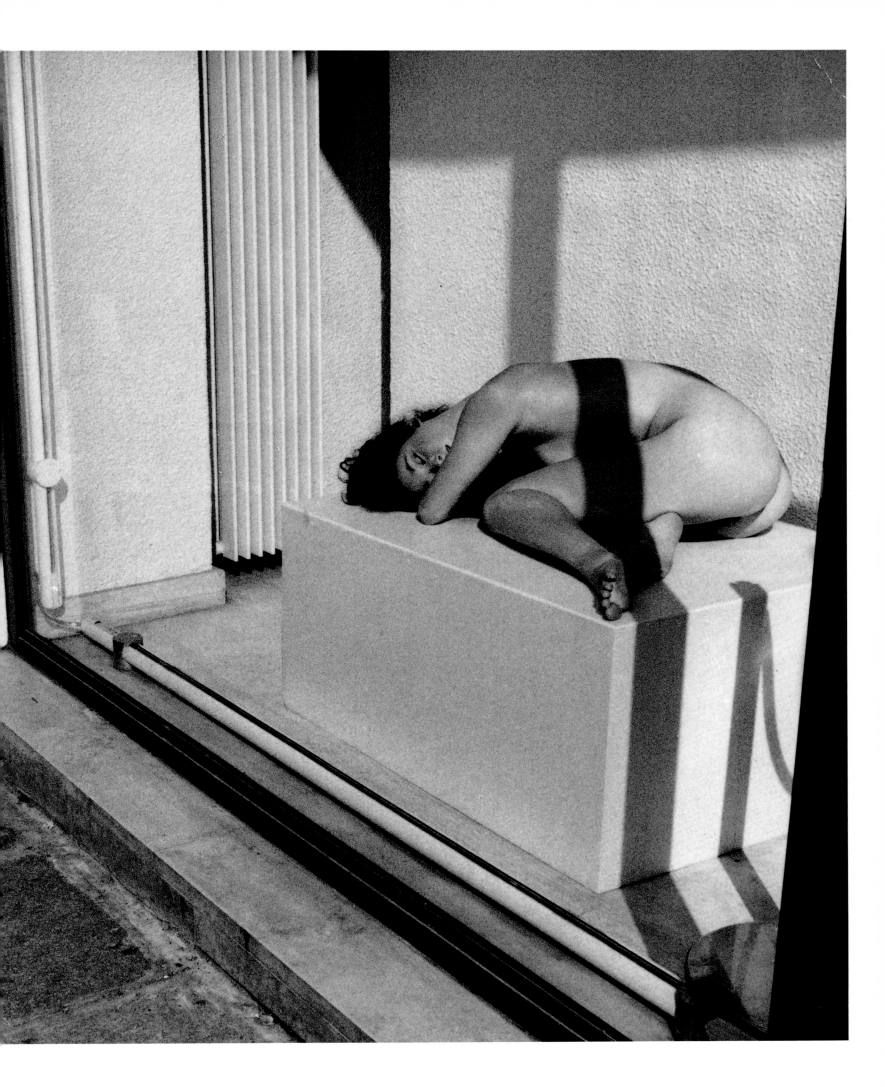

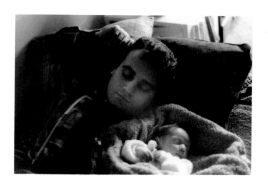

So we fall asleep clutching a Leica,
To impress our dreams on its lens
And recognize ourselves in a photograph,
Awakening to a longer life.

Joseph Brodsky, Roman Elegy

I have always had a penchant for photographing people asleep, but it was many years before I
realized that this had unwittingly grown into something more like an obsession; and even then the
discovery only came to me by chance. I had lost a negative (a common occurrence for an untidy
photographer), and in my search for it was forced to embark on one of those dreaded journeys
through the files of contact prints in my archive.

If reality is, as I believe, the mirror of the photographer and not the other way round, to run
through tens of thousands of images produced by the camera over so many years is like experiencing
a trial run of that hypothetical film imagined by Vitaliano Brancati: one image of one man's face
each day, from birth to death, to be viewed eventually as a speeded-up projection of a life. But in this
case the life is your own.

From a journey like this, as from every journey into memory, one returns with many
anguished feelings, and sometimes with new discoveries. On this particular occasion I realized just
how many of my pictures were of sleeping people; and that I had always been taking such pictures
ever since I started photography, wherever the chances of life and of my job had led me. I decided to
set aside the most decent ones, and ended up with several hundreds. A second, more critical scrutiny
did away with most of them, and I was left with about thirty. These became the nucleus around
which, after seven or eight years of second thoughts, substitutions and new photographs, a first
exhibition laboriously took shape at the Turin Biennale in 1987. I say laboriously, not because I find
taking photographs tiring – on the contrary, it is fun, serious sensual fun, and I'd say light work –
but because something odd, though understandable, had happened. Having become aware of my
obsessive tendency to photograph sleeping people, I began to pounce like a photographic bird of
prey on anybody, man or animal, who dared to shut his eyes even for an instant to steal a nap. The
result was a lot of pictures of people asleep, none of them good. In retrospect this was not surprising,
since I was no longer taking the image as a point of departure from which to explore the fact; on the
contrary, I was taking the fact as a starting point, and trying to impose an image on it. This was the

wrong procedure for me; at any rate it was unproductive.

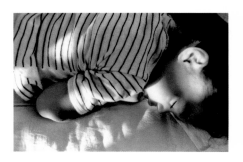

There followed a long purificatory process, lasting a further ten years, during which I forced myself to forget that this was a 'project' on the theme of sleep. Instead of compiling pointless entries for a filing cabinet labelled 'sleep', I had to find new images. I now have thousands, and of these thousands I have chosen, of necessity somewhat arbitrarily, just under eighty to make this book. These pictures, taken over a period of over thirty years, are the provisional culmination – perhaps even the fulfilment – of a long fascination.

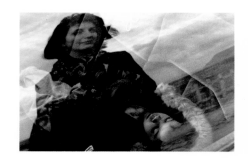

Why sleep, people have asked, and they ask still. I don't think a photographer has to given an explanation, even if he has one, for what he does. Over the years I may have found some explanations for my minor obsession, but they could be false or irrelevant.

To paraphrase Valéry, I practise a kind of photography of the moment that generates form, and of the form that reveals the moment and perhaps also its meaning. Preoccupied in this way with the single instant in the moving flux of life, I feel a compulsion to confront a different situation – the portion of our lives that is essentially motionless, but not stopped. Here time in the photographer's life intersects with time in the sleeper's life, the same, yet different. I find it fascinating to explore in my photographs an event so natural, so ordinary, so universal, but also remote, to which we succumb almost secretly, usually in protected places, aware that we are delivering ourselves defenceless to the whim of others.

It is not by chance that among these photographs there is only one of a little girl asleep in a decent bed, and she is my daughter. The rest deal with people, almost invariably of humble social class, or animals who offer their sleep to our gaze, often in strange situations, whether from necessity, or innocence, or fatigue, or perhaps because they have nothing to lose. Sleep is disturbing; poets are proof that it makes us think of death. It has been said that photography preserves moments of life and at the same time destroys them. There is life and death in sleep and in a photograph.

However, the paradoxical freezing of motionless instants in the sleep of animals or humans has nothing to do with the dead objects of the oddly named genre 'still life' – every one of these photographs deals with real life, talks to us of real life.

If there is no sleep there is no life – insomniacs and bad sleepers who crave sleep so much know this all too well. If there were no sleep we would not even know what it means to be awake and aware. A person who sleeps is a person alive, because sleep is not only the time for rest, it is also the door through which one enters, or leaves, the immense ocean of dreams that some believe to be the most intense form of life.

The bard was right: 'To sleep, perchance to dream'.

Ferdinando Scianna

Ferdinando Scianna was born at Bagheria, Sicily, on 4 July 1943. He began to take photographs at an early age, in 1960. From 1961 to 1966 he studied literature and philosophy at the University of Palermo, where in 1962 he met the writer and intellectual Leonardo Sciascia. The two began a collaboration which continued until the latter's death in 1989. Sciascia wrote the introduction to Scianna's first book, *The Religious Festivals in Sicily* (1965), and subsequently provided the texts for all his major publications, including *The Sicilians* (1977), *The Big Book of Sicily* (1984), and *Hours in Spain* (1988). *Leonardo Sciascia Photographed by Ferdinando Scianna* (1989) is the photographer's tribute to a friend.

The life, rituals and popular culture of his native Sicily have provided the central themes for much of Scianna's work. Through these themes he has defined the language of his art – a language of pure narrative that moves beyond the scientific objectivity of the socio-anthropological approach – and it is to these themes that his work always returns.

In 1966 Scianna moved to Milan, where after a year of local photojournalism he began a long-term connection with the weekly journal *L'Europeo*, first as a photographer working on a great variety of assignments in many parts of the world, and later as a writer also. In 1974 he became *L'Europeo*'s correspondent in Paris, writing on politics, current affairs and the arts. He also broadened his journalistic activities to include writing for *Le Monde Diplomatique* and *Le Quinzaine Littéraire*. A crucial moment came in 1977, when he met Henri Cartier-Bresson, whom he had always admired. The two became close friends, and it was through Cartier-Bresson that Scianna was introduced to Magnum, which he joined in 1982. At the same time he left *L'Europeo* and returned to Milan.

There followed a series of wide-ranging photo-reportage assignments in Europe, Africa and the Americas, several of which resulted in books being published, among them *Hours in Spain, Cities of the World* (1988) and *Kami* (1989). *Forms of Chaos* (1989) is a retrospective anthology that sums up his work of the 1970s and 1980s.

Himself a student of literature and a writer, Scianna has always been interested in the relations between photography and literature, and has collaborated with many writers, including Milan Kundera, Jorge Louis Borges and Manuel Vásquez Montalbán. He also writes photographic criticism for the newspaper *Il Sole 24 Ore*. Since 1987 he has become fascinated by the world of fashion, using the visual language of reportage to interpret the personalities and drama of this self-conscious milieu; on occasion he has blended his earliest and most recent sources of inspiration by setting fashion shoots in Sicilian locations. *Marpessa* (1993) is centred round the figure of a famous fashion model, while *Elsewhere* (1995) is a collection of photographic fashion stories.

Scianna's most recent book, *Pilgrimage to Lourdes* (1996), is in another sense a photographic pilgrimage, in which Scianna returns to his original vocation – to be a teller of stories in images.

Books by Ferdinando Scianna

Feste religiose in Sicilia [Religious Festivals in Sicily],
introduction by Leonardo Sciascia (Bari, 1965).

Il glorioso Alberto [The Illustrious Albert],
text by Annabella Rossi (Milan, 1971).

Les Siciliens [The Sicilians],
texts by Dominique Fernandez and Leonardo Sciascia
(Paris, 1977); Italian translation, *I Siciliani* (Turin, 1977).

La Villa dei Mostri [The Villa of Monsters],
introduction by Leonardo Sciascia (Turin, 1977).

Ferdinando Scianna,
texts by Leonardo Sciascia and Aldo Santini, 'I Grandi
Fotografi' series (Milan, 1983).

Il grande libro della Sicilia [The Big Book of Sicily],
edited by Enrico Sturani, introduction by Leonardo
Sciascia (Milan, 1984).

L'istante e la forma [Moment and Form],
texts by Claude Ambroise and Sebastiano Addamo
(Syracuse, 1987).

Ore di Spagna [Hours in Spain],
text by Leonardo Sciascia, afterword by Natale Tedesco
(Syracuse, 1988); Spanish translation, *Horas de Espana*
(Barcelona, 1989).

La Scoperta dell' America [The Discovery of America],
exhibition catalogue, introduction by Giuliana Scimè
(Agrigento, 1988).

Città del mondo [Cities of the World],
preface by Francesco Gallo (Milan, 1988).

Ferdinando Scianna,
exhibition catalogue, preface by Augusto Bertolini
(Cologne, 1988).

Maglia [Knitting],
text by Guido Vergani (Milan, 1989).

Kami,
text by Ferdinando Scianna (Milan, 1989). [Kami is a
small village in the Bolivian Andes.]

Le forme del caos [Forms of Chaos],
texts by Manuel Vásquez Montalbán and Leonardo
Sciascia, interview by Attilio Colombo (Udine, 1989).

*Leonardo Sciascia fotografato da Ferdinando Scianna
[Leonardo Sciascia Photographed by Ferdinando Scianna],*
text by Claude Ambroise (Milan, 1989).

Marpessa,
text by Ferdinando Scianna (Milan, 1993);
French translation, *Marpessa* (Paris, 1994).

Altrove [Elsewhere],
text by Claude Ambroise (Milan, 1995).

Viaggio a Lourdes [Pilgrimage to Lourdes],
(Milan, 1996).

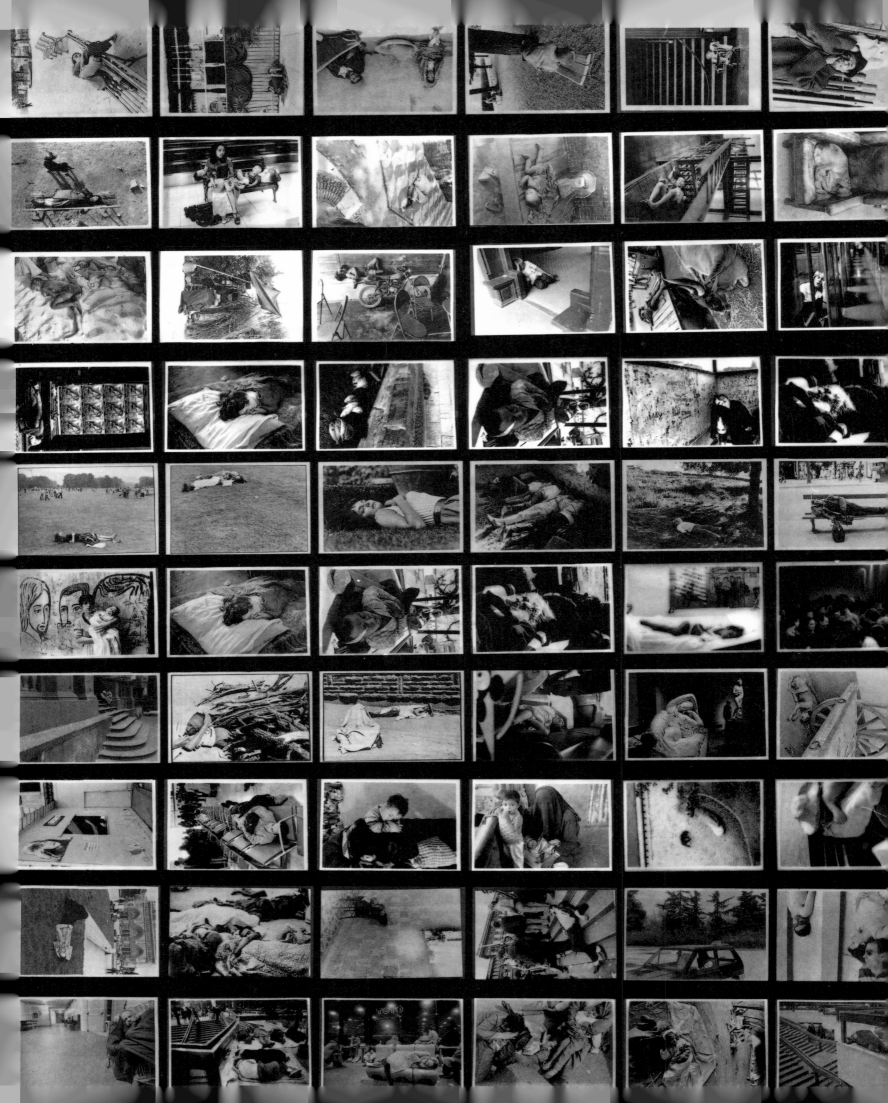